THE PAINTING WORKBOOK

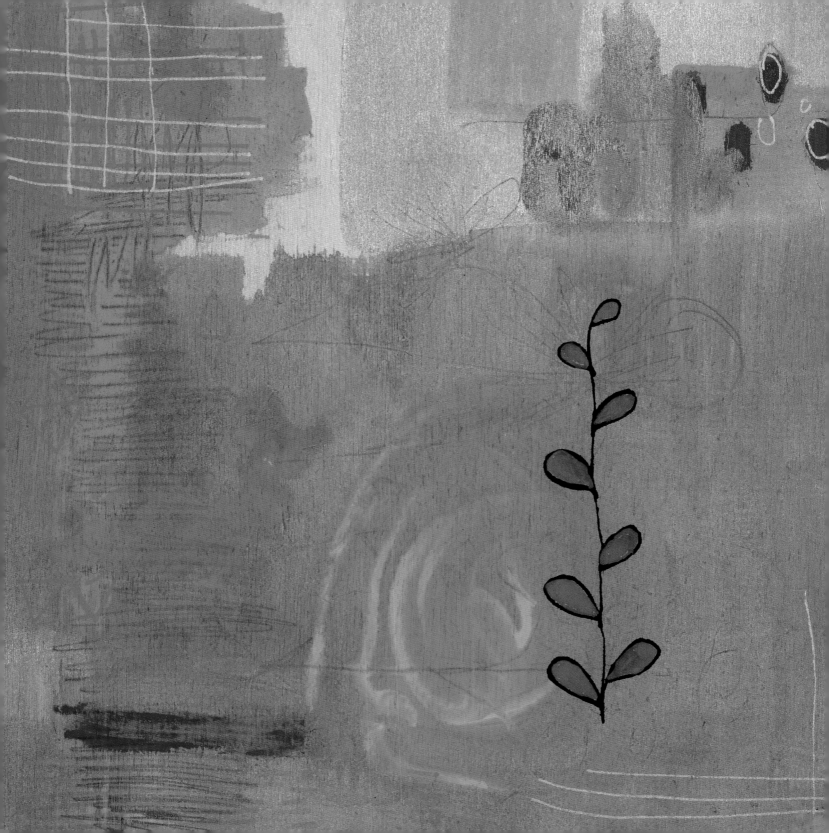

THE PAINTING WORKBOOK

HOW TO GET STARTED AND STAY INSPIRED

ALENA HENNESSY

LARK

Editor:
Rebecca Shipkosky

Art Director and
Cover Designer:
Kathleen Holmes

Photographer:
Steve Mann

Illustrator page 23:
Orrin Lundgren

An Imprint of Sterling Publishing
387 Park Avenue South
New York, NY 10016

ISBN 978-1-4547-0870-4

Hennessy, Alena, 1977-
 The painting workbook : how to get started and stay inspired / Alena Hennessy.
 pages cm
Summary: "Through 50 beautifully illustrated and inspiring prompts, The Painting Workbook offers
readers an opportunity to let go of creative inhibition to express oneself through their very own
personal painting style"-- Provided by publisher.
 ISBN 978-1-4547-0870-4 (paperback)
1. Painting--Technique. I. Title.
 ND1500.H455 2014
 751.4--dc23
 2014007725

Distributed in Canada by Sterling Publishing
c/o Canadian Manda Group, 165 Dufferin Street
Toronto, Ontario, Canada M6K 3H6
Distributed in the United Kingdom by GMC Distribution Services
Castle Place, 166 High Street, Lewes, East Sussex, England BN7 1XU
Distributed in Australia by Capricorn Link (Australia) Pty. Ltd.
P.O. Box 704, Windsor, NSW 2756, Australia

For information about custom editions, special sales, and premium and corporate purchases,
please contact Sterling Special Sales at 800-805-5489 or specialsales@sterlingpublishing.com.

Email academic@larkbooks.com for information about desk and examination copies.
The complete policy can be found at larkcrafts.com.

Manufactured in China

4 6 8 10 9 7 5

larkcrafts.com

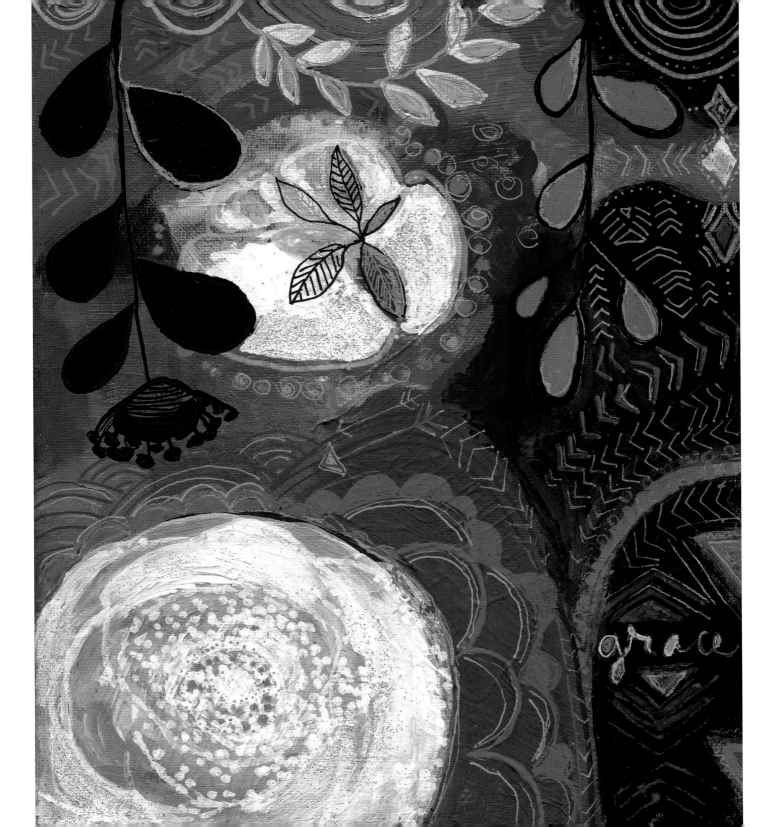

contents

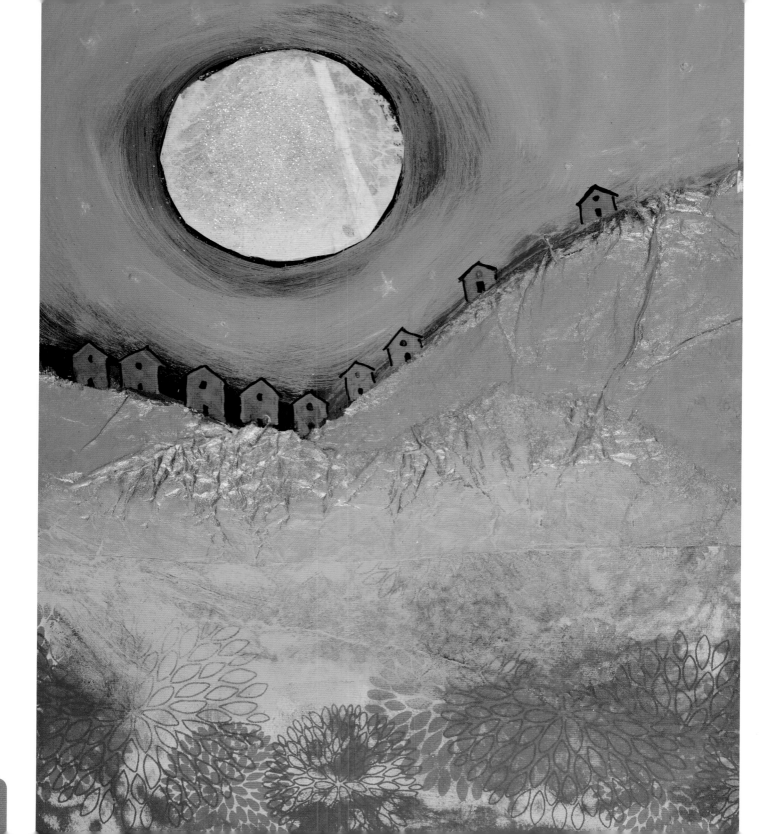

introduction

Welcome to the world of paint! Many come here and enter it lightly, perhaps to dabble, or with some trepidation, high hopes, or a combination thereof. Others come as seasoned loyalists, who just can't seem to get enough of the art form. No matter where you fall within this spectrum, there is one thought that most painters can agree upon: It's a passionate affair.

Painting can bring out our best and worst; it can calm the mind and free the spirit. Painting reveals things to us about ourselves that we may not have been aware of, ways of visually expressing, studying, and exploring life itself. Painting allows us to put colors together most would never dream of, lines that go this way to that, marks that seem to repeat themselves endlessly and without reason, just because we can. Painting gives us room for freedom and a fascinating opportunity for growth.

It takes us on a silent journey, where instinct can be enough, or where obsessive attention to detail can be rewarded. It can give us something new to look forward to each week.

I believe everyone has an artist within, a part that naturally longs to be creative. I encourage you to give painting a try and see what discoveries of our own you can make on the canvas or within yourself. This book offers different ways of seeing, to get your own ideas and inspiration flowing. I have offered many exercises from my own imagination, concepts of what I like to paint, or techniques and styles that can help to free you up. I offer these prompts as inspiration or ways to feed your creative process. Look at them, study, and then make them your own. Your painting won't look like mine, and that's a good thing. We are all unique creatures. Keep exploring and diving deeper into what is your own visual language. Go with what really moves you—whether it's technique or subject matter. I promise, with time and practice, it will not let you down.

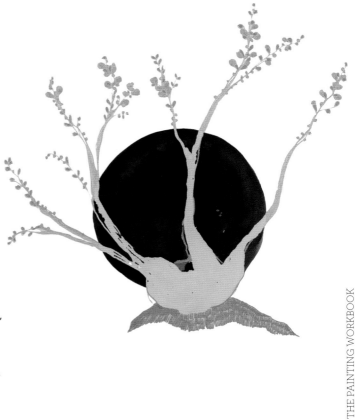

your tool kit

Listed are some suggested materials that I use during my painting process. Nothing on the list is mandatory, and you might have some additional materials you like to use. I will discuss each of the items on the list, along with some fun extras to experiment with. You can find some of these materials at your local art supply store, and almost all of them can be found online.

1. Gesso (page 12)
2. Acrylic paint (page 12)
3. India ink (page 13)
4. Watercolor paint (page 13)
5. Brush sets (page 14)
6. Watercolor pencils (page 15)
7. Water-based paint markers (page 15)
8. Decorative paper (pages 16–17)
9. Scissors
10. Spray bottle (page 17)
11. Hair dryer (page 17)
12. Masking fluid (page 17)
13. Glue (page 15)
14. Varnish (page 15)

Here are some examples of my well-used tools and materials.

tools & materials

PAINTS

Gesso

Gesso is a type of white paint meant to be used as a base for other paints. A lot of artists buy blank canvases or wooden boards and paint gesso onto the surface themselves, while many others prefer to buy pre-gessoed products. This base coat creates a smooth surface to paint onto, since canvas and wood are textured.

Acrylic Paint

Acrylic paint is a water-based paint that works well on a variety of surfaces. Its drying time is rather quick, and it serves as a perfect medium for backgrounds and layering. Acrylics come in a variety of pre-made colors, from bold to pastel to fluorescent, but you can easily mix it to make any color you like. It can be sealed with a varnish or built up with layers of gel medium (see page 15 for more on gel medium and page 56 for more on layering).

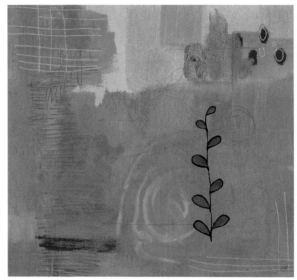

I sometimes like to paint on untreated wood for that raw look, where I will use ink as my "gesso," or background.

The beauty of working with ink is that it exhibits the fluidity of water. India inks also come in iridescent colors, which add a subtle sparkle to your work.

Ink

India and acrylic inks are a couple of my favorite media. It works best on a wet surface. The colors are deep and rich in hue, becoming lighter as you add more water. It can also have lovely gradual and fluid effects. India ink serves quite well as a background for painting on certain surfaces such as watercolor paper pressed to a panel or gesso wood, and as detail work on paper. I have also found that iridescent inks add a magical and shiny quality that I really like.

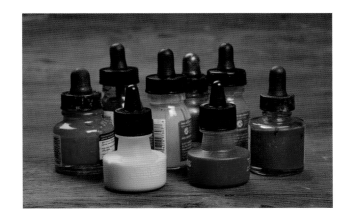

Watercolor Paint

Watercolor paint is transparent, and it works best on paper. It has a gentle and delicate effect consistent with the translucency inherent in the medium. Like India ink, it will be more saturated or diluted depending on the amount of water you use.

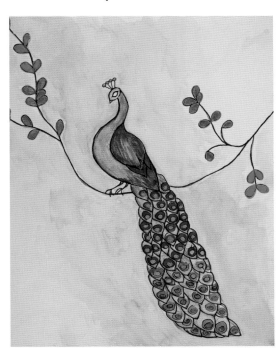

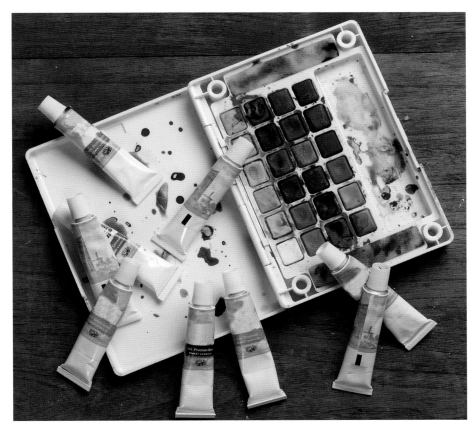

Brushes

You will want to purchase a variety of brushes for various paints and techniques. Brushes are available for any type of paint you like to use, and many are appropriate for more than one type. As for acrylic, watercolor, and ink, some brushes can be used for all three. Art stores sell brush sets that include a lot of the brushes you will need. Whether or not you buy a set, make sure to purchase a range of small to large brushes.

If you work small and in more detail, you will obviously need more of the smaller sizes. The same goes for working large and large brushes. FLAT BRUSHES are good for background surfaces or larger flat areas or washes. For organic lines and shapes, ROUND BRUSHES are helpful, and they also hold more water, so they're handy when you want a very diluted paint or ink. I love small round brushes for detail work, and I use ANGLED BRUSHES for cutting corners and applying flat surfaces. FAN BRUSHES can be used to blend colors or create highlights, or to paint things like hair. FILBERT BRUSHES are good for detail and organic shapes, and they also provide good coverage.

SHORT-HANDLED BRUSHES are said to be good for ink and watercolor, while LONG-HANDLED ones are best for acrylics or oils. If you are working small, you definitely will want to use a short-handled brush, but other than that, I have found it does not matter much.

Brushes also come in a number of varieties. SOFT SABLE, or synthetic sable, is good for ink and watercolor, and for applying thin applications. NYLON or SYNTHETIC BRISTLES are used for acrylic paint. If you use oil paint, you will want to use bristle or sable brushes.

FOAM BRUSHES are also great for backgrounds and adding large flat areas of paint, as well as mark making. They are also a very economical alternative to other brushes.

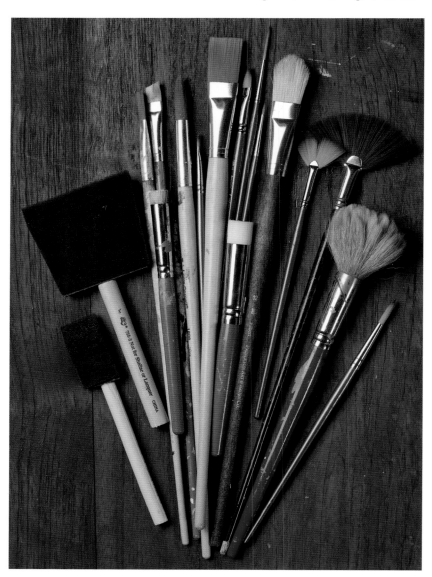

DRAWING TOOLS

One thing that is perhaps unique for my style of painting is that I like to incorporate drawing media into my work. I have found WATERCOLOR PENCILS to be fun tools to use. You can add them directly into the wet acrylic paint, and the pigment gets dragged or reveals the layer underneath.

WATER-BASED PAINT MARKERS are perfect for adding detail on top of the dry painting, such as words, outlines, or fine marks. The markers come in extra-fine to broad points, so you can choose which effect works for you. I personally like the extra-fine point, because they lend themselves to more detailed work.

ADHESIVES

Painting mediums work well as adhesives, for doing transfers, or for providing a final coat on your work. MATTE MEDIUM can be used for collaging, but only if you're adhering thin papers. GLOSS MEDIUM works the same way, but it has a more shiny effect. GEL MEDIUMS are good for photo transfer and also work really well for collaging and for extending paint to get the most use out of it. Layers of gel medium can sometimes be used to add thick or sculptural peak effects and textures. If you want to glue down heavier objects for mixed media work, however, such as coins, glass, or beads, CRAFT GLUE may be required. PAPER CEMENT is your best bet if you do a lot of collage work, because it won't wrinkle the paper.

PROTECTANTS

MATTE AND GLOSS VARNISHES or MEDIUMS add a final layer to protect and seal your painting. A large flat brush is the best kind for applying finishes. A UV-RESISTANT CLEAR SPRAY (or spray varnish or fixative) also comes in matte or gloss and is good for protecting the work against ultraviolet rays. EPOXY RESIN adds a thick layer, an almost glass-like surface, to your work. Resin needs to be applied in a well ventilated area and takes several hours to dry, so you will need to monitor or protect your work from dust that may fly into it. I often need a second person to help when I'm working with resin.

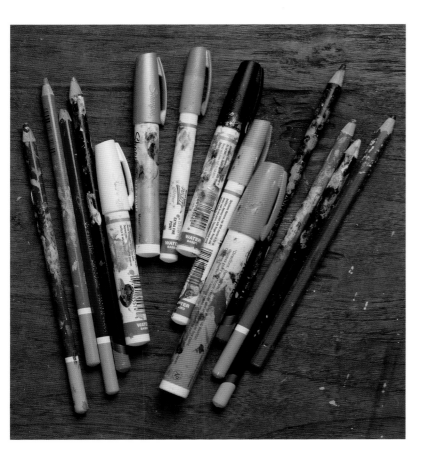

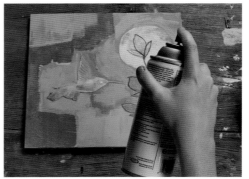

SURFACES

Canvas

Canvas is the most common painting surface. It is made from tightly woven fabric, and it has some slight flexibility. Canvas comes in a variety of fabrics, from linen to cotton. The frame that gives a canvas its shape can be any one of a variety of depths anywhere from a gallery depth of 2 inches (5.1 cm) to basically flat, like a canvas board, which will need to be framed.

Wood

Fine art painters have used WOOD PANEL, my personal favorite surface to paint on, since the beginning. I prefer lighter woods, and many of those you can find online at art supply shops. COATED HARDBOARDS are another favorite for ink and mixed media. AQUABORD™ and GESSO PANEL are also popular with many artists I know. These wood panels, like canvasses, come in a variety of depths.

Paper Products

Just plain old paper is best when you're painting with watercolor or ink and want to frame or mat your work once it's done. There are a variety of archival watercolor papers out there, from high end to student grade. COLD-PRESSED PAPER has the texture left in it, while HOT-PRESSED is very smooth.

Within reason, you can almost paint on anything you wish. Alternative surfaces such as CARDBOARD offer economical and eco-friendly ways to reuse materials. Some artists like to paint on METAL, old WINDOWS or DOORS, or other FOUND OBJECTS.

FUN EXTRAS

There are a variety of DECORATIVE PAPERS out there, from handmade Nepalese paper, to that of the lacey, feathery sort, which can be added to your painting to create a mixed-media piece. Old notes from journals, newspaper clippings, or drawings from a

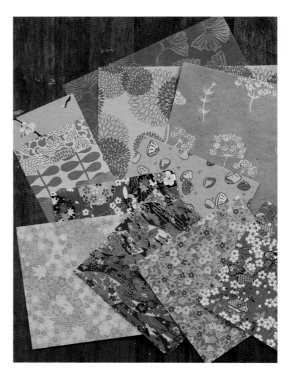

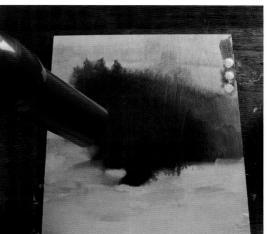

sketchbook can all be added into your painting using the proper techniques and materials. The key is to press them down using a flat surface, make sure they are adhered with a gel medium or other adhesive, and varnish them once they're dry. The thinner the paper, the less thick the adhesive needs to be, and vice versa.

A spray BOTTLE can be used to keep a surface wet, when you want to keep pigment fluid and mixed on the surface. This comes in handy when you're painting with acrylics, watercolor, or with India ink.

A HAIR DRYER is quite helpful when you're painting with acrylics and you want to speed up the drying time between layers.

FOUND OBJECTS offer a wonderful way to incorporate personal or found ephemera into your work. Keys, doilies, fabric, metal, feathers, beads, and plenty of other magical items can be adhered to a painting.

FINE GLITTER is another way to add an extra sparkle or shine to small areas of a painting. Fine art glitter can now be found at most art supply stores and comes in many colors.

MASKING FLUID acts as a resist when added to surfaces such as watercolor paper. It is a removable, almost-colorless fluid that dries into a rubber- or glue-like consistency that can be peeled off once everything is dry. This allows you to control the spread of otherwise fluid media like watercolor paints and inks by masking certain areas you don't want painted and then painting onto the paper. You can use a rubber-cement pick-up or your hands to peel it off. Once you remove the masking, you can leave those areas white or paint them in. (See pages 66–69 for more information.)

PRESSED PLANT MATERIALS, such as leaves and flowers, can especially work when sealed with a heavy protectant like two-part epoxy resin.

Spray-painting over a STENCIL, whether pre-made or homemade, offers a fun and quick way to create a 2-dimensional image or a repeated motif or pattern anywhere on your work.

SPRAY PAINT, especially the water-based kind with low odor, offers a fast and satisfactory result for painting. My favorite way to use spray paint is with stencils, but it can also be used for under-painting and for creating an even background in a large-scale work.

Copies of old PHOTOS or OTHER IMAGES can be transferred or otherwise incorporated to add a nostalgic and personal narrative your work.

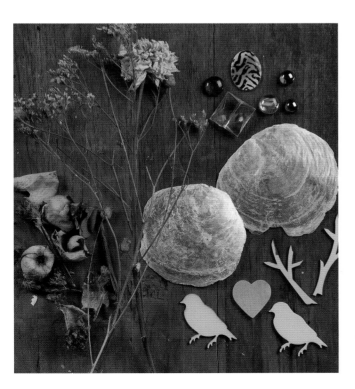

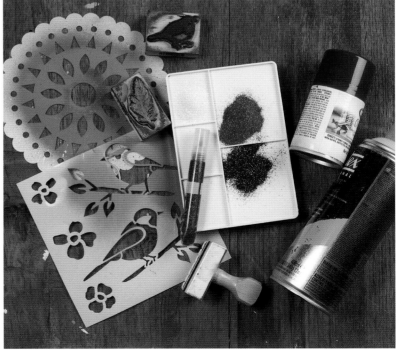

getting started

DISCOVERING YOUR MUSES

In the practice of creating, I believe it's of utmost value to find what authentically moves your unique sensibilities and to work from that place of inspiration. Are you inspired by patterns, bright or muted colors, linear detailed work, or wild sporadic lines? Do landscapes, portraits, owls, foxes, flowers, minimalism, high contrast, or a combination thereof move you to create?

Spend time looking at art and design in a host of ways. Magazines, books, and online social networks can educate your eye on what clicks for you. Visiting a local museum or gallery can prove to be full of visual input and stimulation. Do not copy, but just make mental notes. Understanding art history, from its origins to now, can also help educate your eye and

inherent aesthetics. As artists, once we understand the range of work out there, we can begin to know where our own natural hand has its place.

Once you have taken in a lot of work and fed your eye, so to speak, you can then express outwardly. Grab a sketchbook and begin doodling ideas for work. Maybe you will want to grab a book of symbols to develop a narrative quality within your work, or simply sit outside and draw what you see. The important part is to practice and get comfortable with your own hand. When we work from a place of comfort and knowing ourselves, we will feel better about our work. The viewer can also gain a sense of our visual language and the true nature of how we like to create.

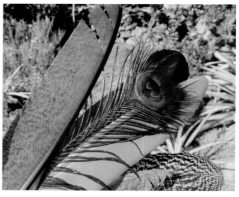

A COMFORTABLE SPACE

Setting up a space where only you get to create is equally important. Artists' studios are their places of refuge and quiet, where all the ideas and magic can pour out. Whether it is a large table in a corner of your house, a spare bedroom, a renovated basement, or even a rented space down the street from you—make it your own. I have to admit, sometimes when I work from home, I take over a good bit of my house too and it can get kind of wild and messy—and that's OK.

I have had both polished retail storefront studios and easels in the corner of my bedroom, but the important part was that I had a space to make art. Make sure you are comfortable in your creative space, you can work with ease there, and you have access to all your supplies. Having some sort of order will help motivate you to create whenever the urge strikes you.

EXPLORING THE CITY

A beloved pastime of mine is to take my creative self into the city for the day—any city will do, your hometown or one you are visiting. It's true some may feed our inner artists more than others, but it seems the intention of taking yourself on an outing is good enough to fill the well.

Go visit art stores, antique stores, used bookshops, clothing boutiques, museums, galleries, thrift stores, home décor spaces, and more. Take your camera, or your Smartphone, and a sketchbook with you. Snap photos of color combinations you like or sketch down any notes. Be sure to go visit a bookstore and look through the art history section. Browse paintings and make notes about ones that moved you and why. Notice every detail about these paintings and figure out for yourself just why you are drawn to them. Come home, rest, refuel, and begin painting that day or the next.

WALKING THROUGH NATURE

Getting out into nature is a beautiful way to inspire the artist within. Go for a hike in the woods, take a boat on a lake, walk on boardwalks, visit a nearby park or botanical garden, and notice every little bit around you. Again, take your camera and sketchbook, and make notes. Draw shapes, lines, imitate textures, and note colors.

Nature is bold, not shy, so allow yourself to give your work that same permission. Write down thoughts that come to you when you are still and quiet. Think of this time as your time to fill up on ideas for painting and see how your experience changes through all your senses.

the elements of art

The elements of art are the foundations, or basic properties, that a viewer may perceive when taking in a work of art.

Line: the path of a moving point.

Shape: two-dimensional defined areas; can be organic or geometric.

Form: a three-dimensional space showing height, width, and depth.

Color: the use of hue in art.

Texture: what can be sensed by touch.

Space: areas around, within, or between things.

Value: the use of light and dark in art.

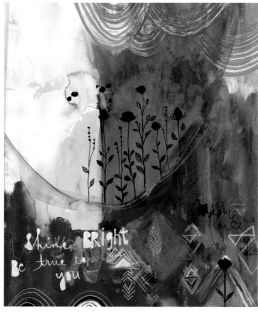

*You can see the use of **lines** in various places, from the half circles swooping down from the top, to the details in the feather and flowers. Triangular **shapes** and implied half circles create a sense of activity, as does the use of bright, contrasting, and complementary **colors**. The interaction of color in the half circles at the top imply **texture**. There is also an implied sense of **space** between the foreground, middleground, and background elements.*

PRINCIPLES OF ART

The principles of art are the keys, rules, or tools that organize the elements in a work of art.

Movement: demonstrates action or paths in a work that the viewer's eye will follow.

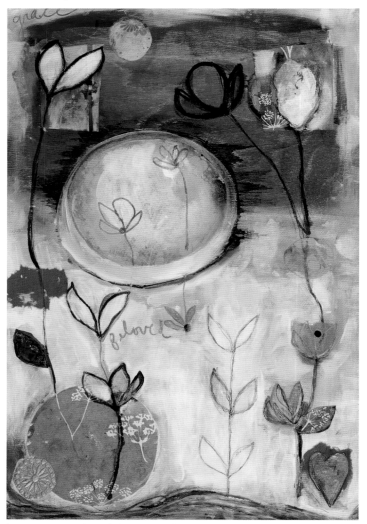

Movement can be subtly implied. Here, the stems of the plants provide the viewer's eye a path to follow around the painting.

Unity: how well all the elements in a work of art come together and build upon one another.

Unity can be a central motif or subject where the other elements dance around or support it.

Harmony: a work that contains like elements throughout is said to possess harmony.

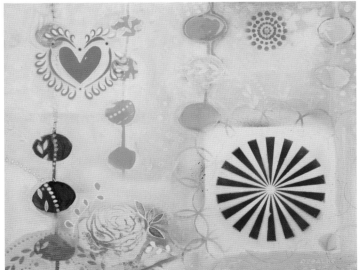

Here, harmony can be found in the repeated circular elements and shapes, along with the gradual change in the white background.

Variety: differences in form, size, and color, along with the use of contrast and emphasis.

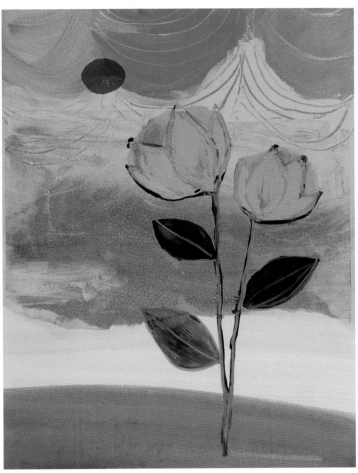

The quick, tiny, drawn-in lines and the broad brush strokes, along with the use of complementary colors, lend this piece its variety.

Balance: elements of a piece working in an arrangement so that one does not overpower the other.

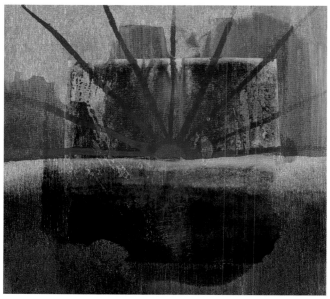

The use of strong and complementary colors help to balance the two halves of this piece.

Contrast: the variance between light and dark values or colors.

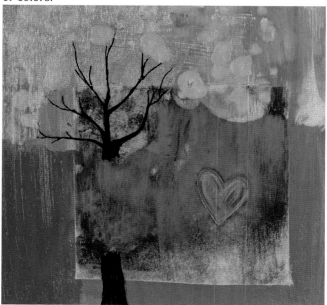

Dark or cool colors recede and warm or brighter colors come forth, thus providing contrast.

Proportion: the relationships of size and quantity of the elements in a work.

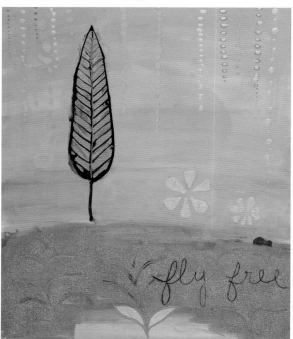

The large feather and tiny dots help to demonstrate varied scale or proportions.

Rhythm: repeated marks or consistency with lines and colors.

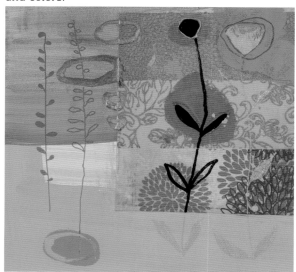

Tiny circular leaves and other subtle circular shapes demonstrate rhythm in this piece.

color theory

Color theory is the study of color mixing and the visual impact that each color combination has. Artists and philosophers first came to write about color theory in the 18th century. The study of color combinations and the wheel grew from there.

Having a basic understanding of color theory can help inform your painting decisions and give you some structure when choosing hues. I also believe that once you understand the color wheel and all its variations, using your intuition when choosing colors is just as effective as any other method, if not more.

Primary: Red, Blue, and Yellow are the primary colors.

Secondary: Orange, Green, and Violet are the secondary colors.

Tertiary: Red Violet, Red Orange, Yellow Orange, Yellow Green, Blue Green, and Blue Violet are the tertiary colors.

Hue: a color at its purest intensity.

Tint: a hue mixed with white, also called pastel.

Shade: a hue mixed with black.

Tone: a hue mixed with grey.

Monochromatic: a color scheme containing one hue modified by the addition of black, grey, or white to make different tints and shades of the same color.

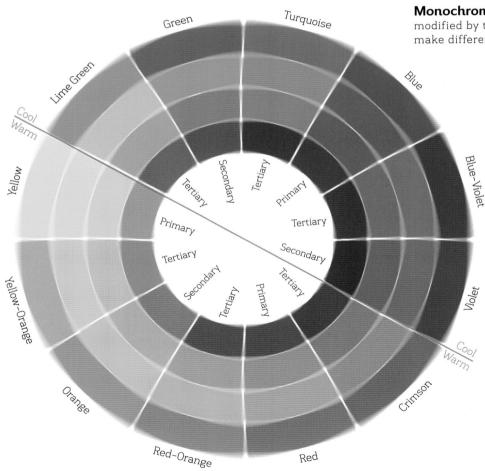

Warm/Active: the reds, oranges, and yellows of the color wheel. Tend to come forth and are often associated with fire, heat, and the sun.

Cool/Passive: the blues, greens, and blue lavenders of the color wheel. They tend to recede visually and are often associated with sky and water.

Complementary: colors directly across from each other on the color wheel, thus having the greatest contrast. Complementary color schemes tend to be vibrant and possess a bold and active feel. When mixed, complementary colors tend to get muddy-looking and neutralize.

Analogous: groups of colors that are adjacent to one another on the wheel, with one being the dominant color and the other two on either side complementing the primary color. Analogous color schemes have a rich monochromatic feel with just a little more depth, and are best used with either exclusively cool or exclusively warm colors so that the feeling of the work has harmony.

Triad: three hues that are equidistant on the wheel. A triad color scheme will give you a balanced, yet bright or contrasted feel, although not as strong as a complementary scheme would.

basic techniques

WET ON WET

This painting technique is used traditionally with oil paint, but you could also use it with watercolor and India ink. Essentially, you wet a surface such as paper or Aquabord™, and then apply the paint in a wash (an evenly distributed amount of color that can serve as a background). Then you add other pigments on top of it to build color. As more layers are added, the effect can range from diffused and subtle, to feathered and irregular with serrated edges, to highly saturated.

DRY ON DRY

Another painting technique used when a relatively dry brush picks up paint and applies to a dry surface. The effect can give a scratchy, textured look where you can build up thick layers.

FLAT VS DEEP

One thing I have noticed in painting is that a work can have a depth, or perspective, where it invites the viewer's eye to explore back into it; or it can be flat, where it's mostly based on certain elements of art, such as color, line, or pattern. A painting may also have depth in some places and be flat in others, but generally, a work falls into one of these two categories. I happen to work in both ways, but many artists are loyal to one or the other.

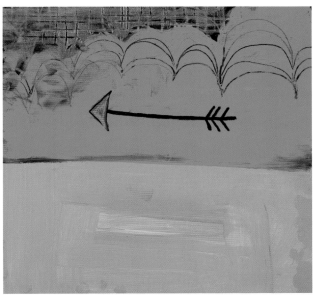

This work has a flat, or pushed-up-to-the-surface feel, with its broad areas of color and minimal variation.

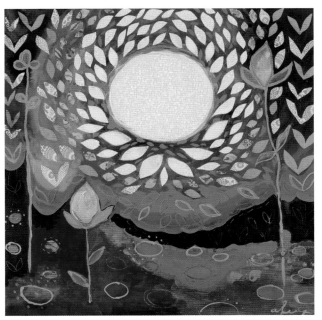

Here, the plant forms in the foreground with their warmer hues, along with the dancing leaves and moon in the background with their cooler hues, help to create depth.

POINT OF VIEW

As you deepen your understanding of painting as a rich and layered medium of expression, it's valuable to develop your unique point of view or style. This will be gained through practice, exploration, and study of the medium. As I said before, having a broad knowledge of art history and how painting is being expressed in its current state helps us understand what we are naturally drawn to. Exploration and practice are key, though, so doing the work is of utmost importance. Continue to explore how your hand moves and what you are drawn to. Also, make a decision within yourself as to what you want to share with the world in the visual sense.

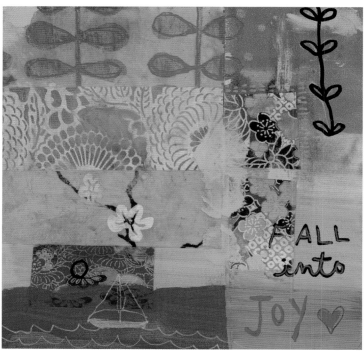

Your paintings offer an opportunity to express your values, beliefs, or inspirations.

PAINTING AS PLANNING

As I said in Flat vs Deep, artists can go about creating a work in one of two ways: planned out carefully, or intuitively expressed. This is not to say that both cannot occur within one painting, or that all artists necessarily go about both ways in their work, but it is of value to consider this when you begin to create.

A planned work is one that may involve sketches with a pencil in a sketchbook, and perhaps color sketches with paint and so on. In other words, you take your time and think through or practice each step before you start and as you work. You may think carefully about what symbols or story you want to share, which exact colors to work with, and so on. Again, you can interplay between planning and allowing for a little in-the-moment awareness.

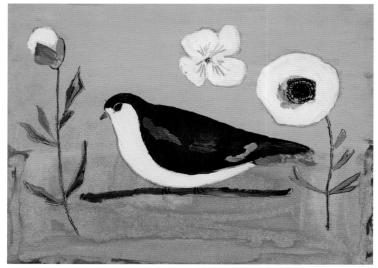

This is an example of a painting I began by planning it out. I had a very clear picture in my head (and my sketchbook) of what it would look like before I even put paint to board.

PAINTING AS PROCESS

Many artists I know work intuitively when painting, or by what moves them in the moment. It's as if, within the process of painting, the paint will reveal to you where to go. How you react, add, or back up each layer as you work, and how you experiment on the surface, is very much a part of Painting as Process.

Painting as Process is obviously a wonderful way to carry out an abstract painting. It's a liberating way to create, and it will allow you a lot of play and freedom with the medium. If you watch children make art, they tend to create this way, not giving much rational thought to the plan, but just allowing their expression to come through in a natural way. This way of painting asks your inner critic to sit back and trust the process. In this way, you reserve judgment, and your intuition can guide you along the way.

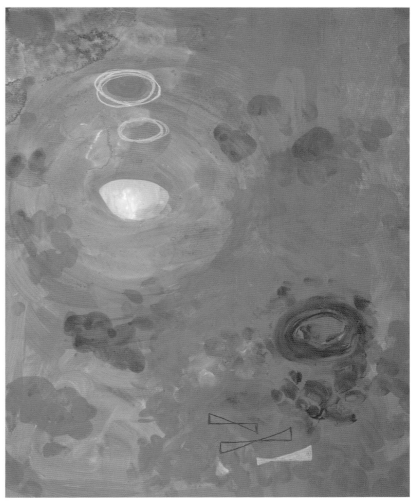

I most often work intuitively. This is one of many examples of Painting as Process.

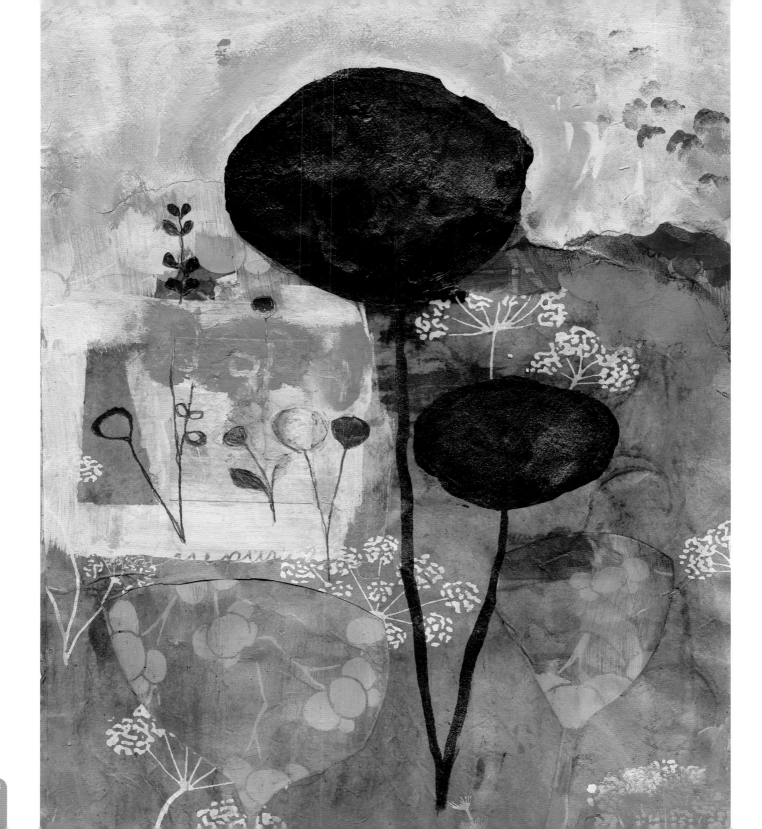

the creative life

The creative life is where one must refill the cup of inspiration often; notice detail and vastness, or perhaps easily become enthralled by texture, pattern, and color combinations. Painting may also be about your own personal narrative, perceptions, or beliefs. Other times it may be simply about technique, design, or exploring materials. Thus, diving into the world of painting can offer up a lifelong romance, one where the learning never stops, nor does the challenge, desire, and sometimes obsession to create.

It almost beckons you to be uncommon, true to yourself, authentic in your everyday expression, and to be less concerned with rules or norms. In painting, you get to make up your own rules, while honoring technique and tradition. No two artists are alike, no matter how similar. It's the infinite amount of differences in the way humans express themselves that makes the visual art world so interesting.

We get to play, honor, release, intend, dream, revere, simplify, complicate, and unify all the elements until it clicks and feels complete. Whether painting is just a hobby or it's a full time passion, there is one thing for certain: it makes for a delightful and fulfilling way to pass the time. Painting invites you to be challenged and quietly pleased through every step of the process.

SOME SAFETY INFORMATION

When painting, make sure to keep your studio or work area ventilated when you're working with materials like epoxy resin, spray varnishes, or other potentially toxic media. If you decide to work with epoxy resin, make sure to follow the directions and wear a mask and gloves. If you paint with your fingers, be sure to wash your hands immediately and thoroughly after. Make sure children or pets do not ingest paint or any other art media. Always use caution and common sense when working with synthetic materials or sharp objects.

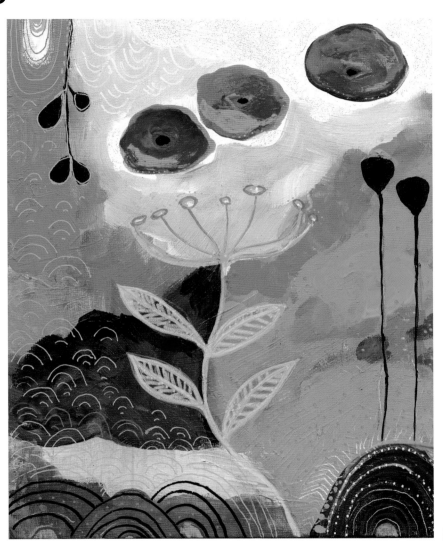

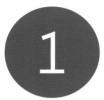

color pairs

Limiting your palette to just two colors (along with tints and shades) can be a fun way to study colors and the way they interact with one another. See this as a productive and simple way to try new ideas, colors, and color combinations. Be free and bold with your strokes. Try painting a single, simple subject. Keep your focus straightforward and clear.

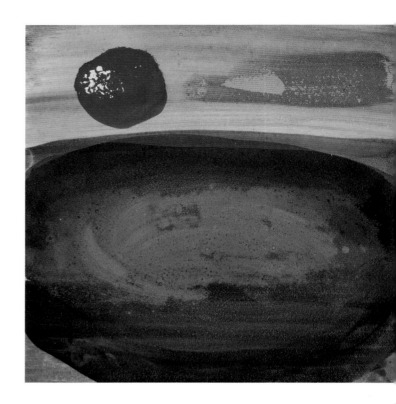

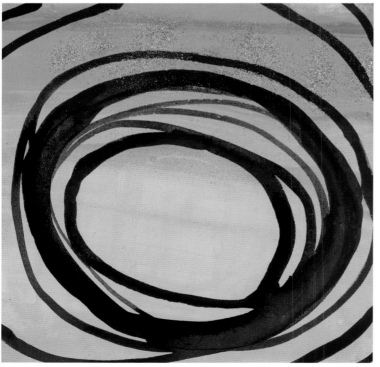

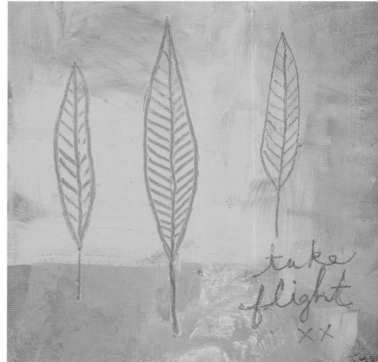

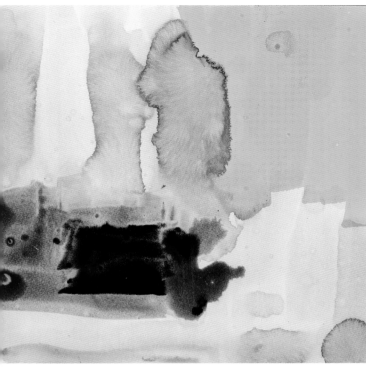

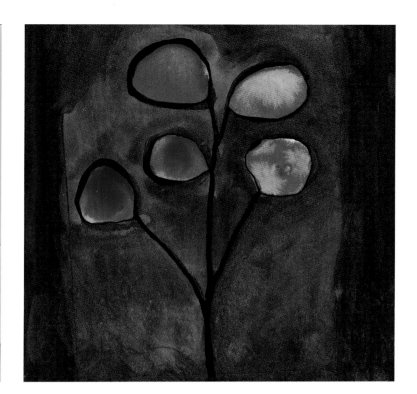

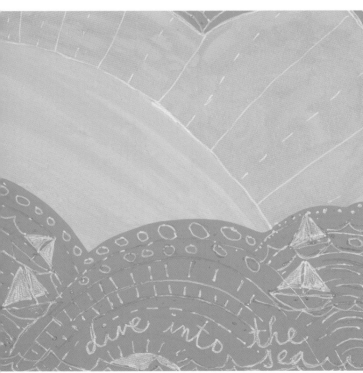

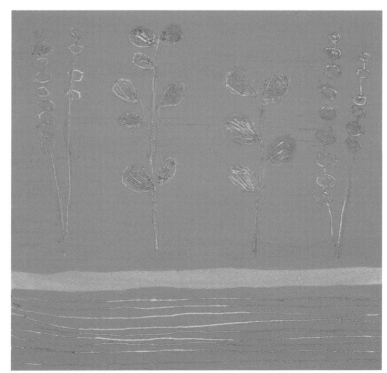

2

monochromatic play

Minimizing your color palette can be an interesting practice to try out. A monochromatic color theme involves the use of one color (or hue), plus black and white to make different tints and shades as well as grey. The work will often be more subtle or simple and less vibrant. A monochromatic work can make a strong statement, set a mood, or just match the palette of a room's décor.

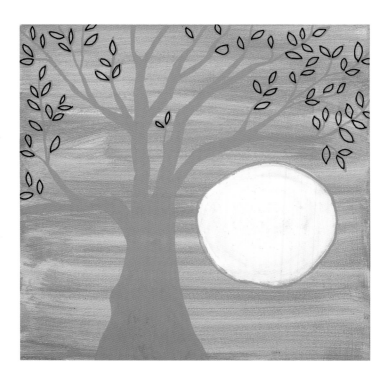

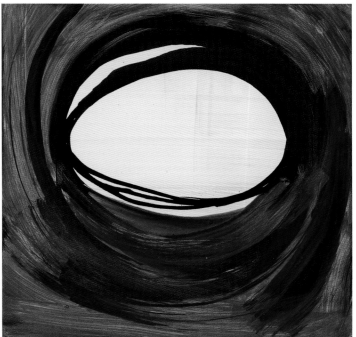

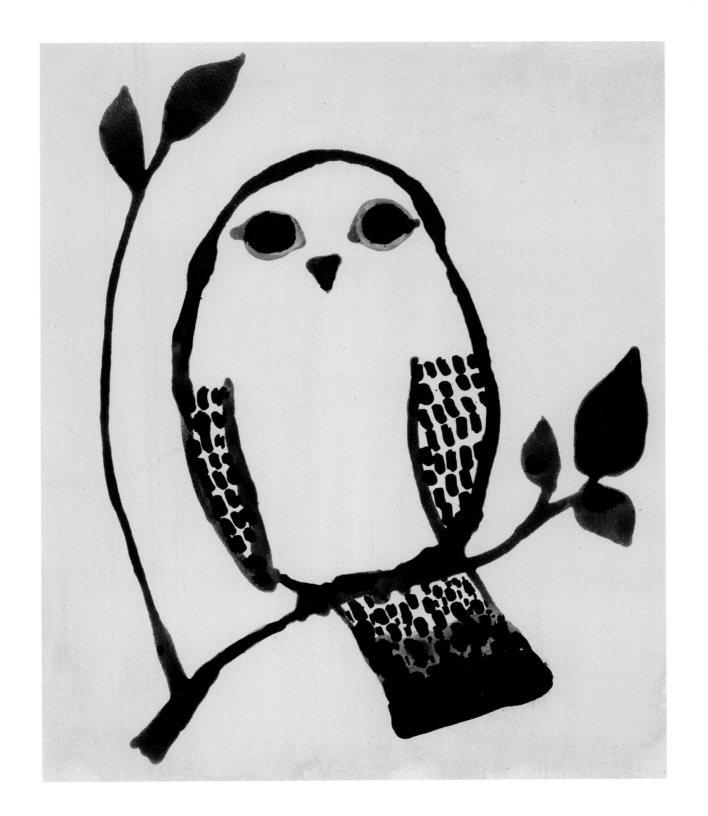

silhouettes

Silhouettes represent a concept that I enjoy executing in painting. I find the simplicity captivating, and it brings a clear focus onto the beauty of shape. A silhouette is a dark shape or outline of something against a lighter background, so find things that delight you and create this type of work to enhance your understanding of contrast and shape.

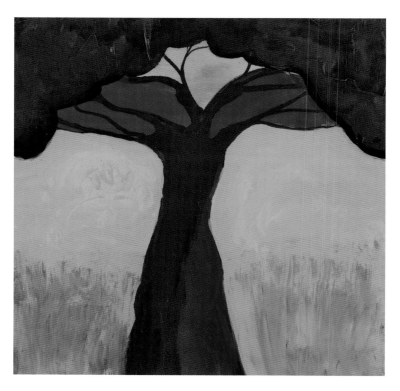

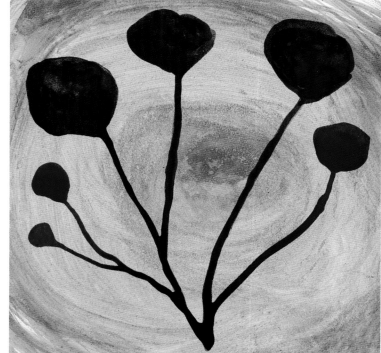

awkward colors

Working with colors that are counterintuitive to you, or ones you would not likely choose, can be a exercise to push through any preset ideas or boundaries you may have set for yourself as an artist. You might be surprised and find you like one or more of the new colors, thus expanding your personal color wheel.

black magic

Using black as a predominant or unifying color can create a strong contrast. The feeling conveyed in a mostly black-on-white painting might have more of a nostalgic or simplified narrative than one that features lots of bold colors. Colorful paintings tend to offer a more literal interpretation of reality. These works were made using India ink and acrylics on Aquabord™. Using a touch of color in a black, white, and grey theme can create a strong focus on that color.

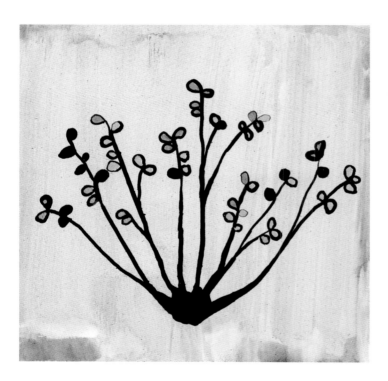

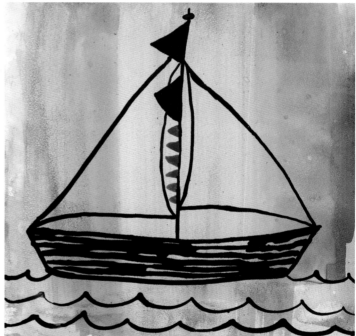

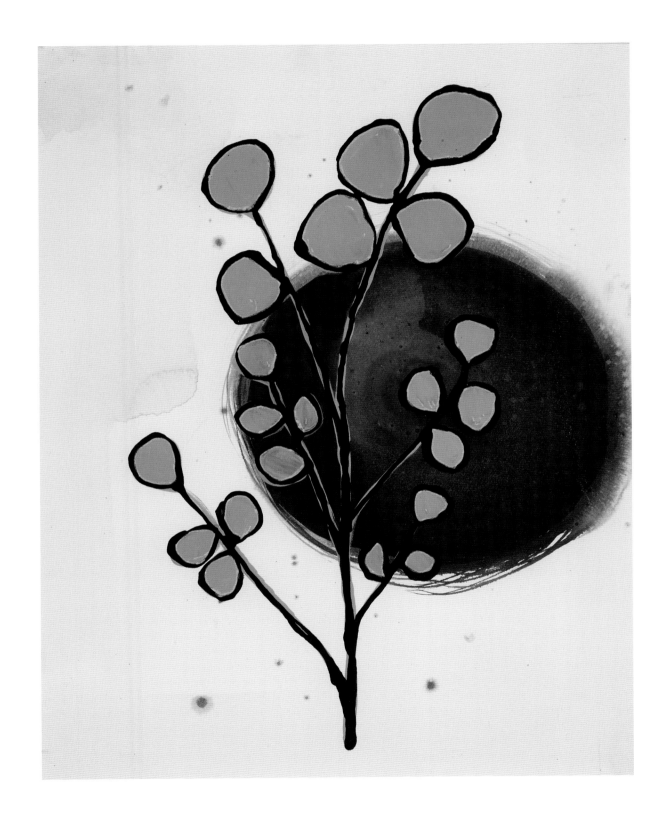

white on white

As seen in Mark Rothko's work, keeping things minimal can still be powerful and evoke certain feelings. Create works with different shades of white using paint, paper, or even by adding found objects. White-on-white works can evoke a feeling of softness, or you can add just a touch of color to create contrast.

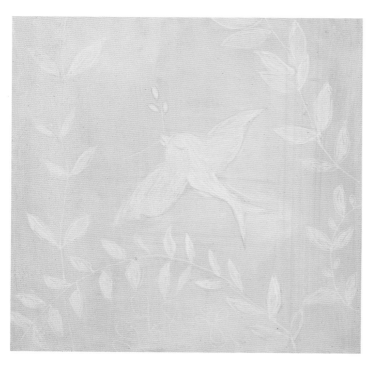

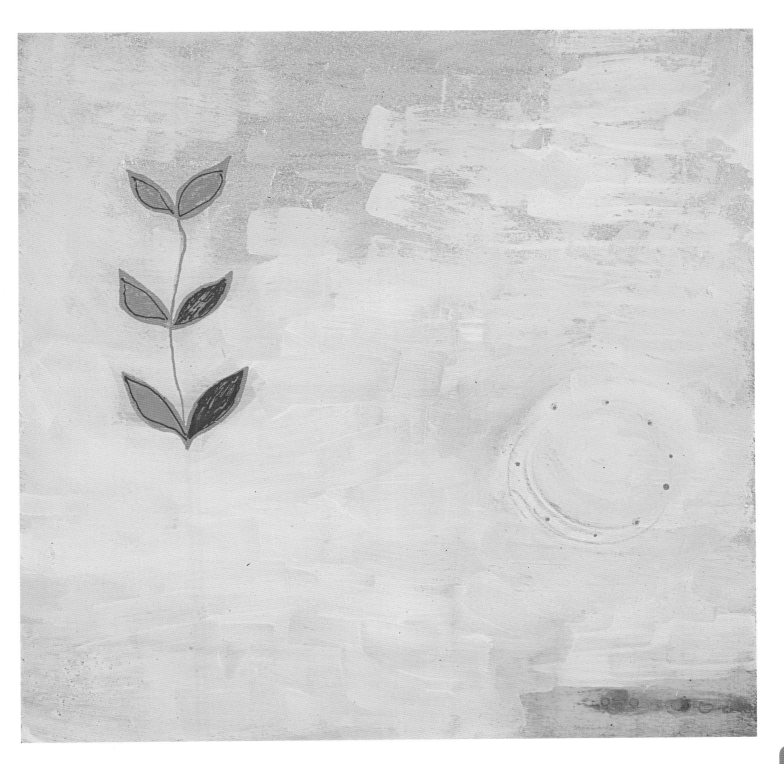

opulent hues

Inks, acrylic paints, and paint pens are all available in metallic or iridescent hues that you can use to create an opulent and shiny effect. Experiment with this type of pigment for a whole painting or just a touch.

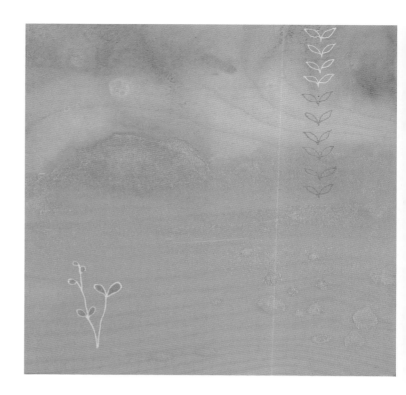

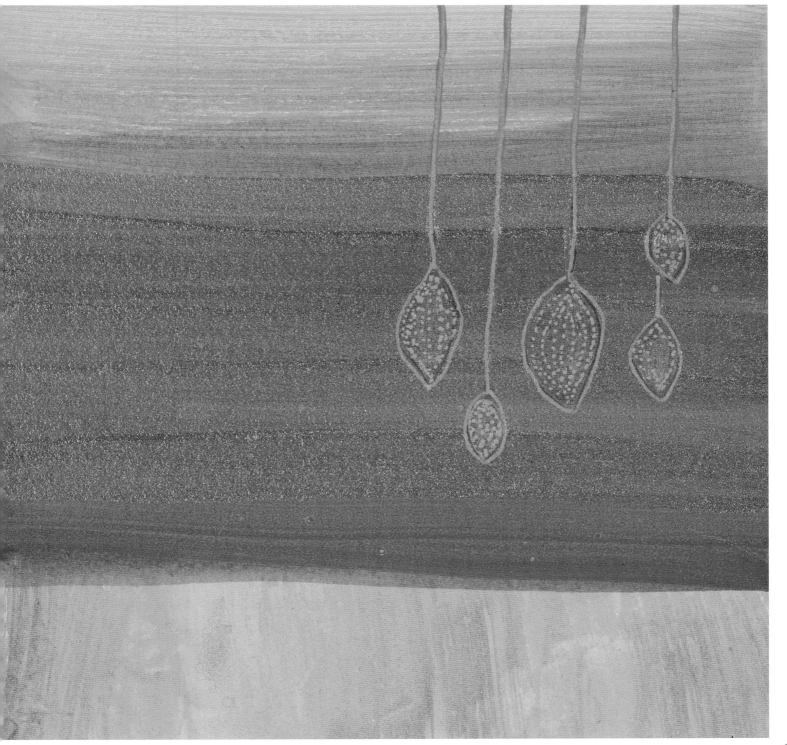

let it seep

Drip or paint some India or acrylic ink onto a wooden board and create a fluid painting that spreads naturally across the wood's grain. Saturating a wood panel with water and heavy amounts of layered India ink can be a neat way to experiment with fluidity and movement, as well as create a strong abstract painting focusing primarily on hue. The more layers of ink you have, the deeper and richer the color will be. *Mini-Workshop to follow*

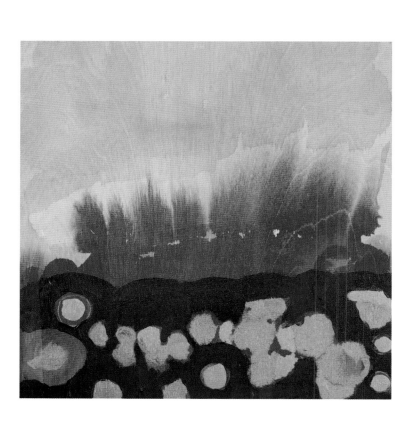

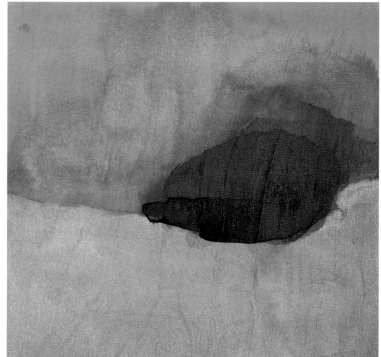

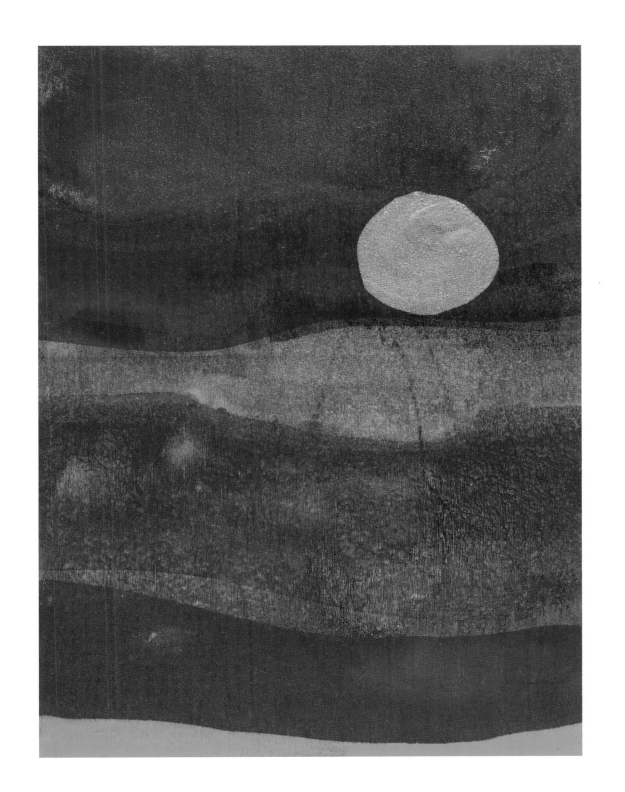

Let it Seep
Mini-Workshop

you will need

- A variety of brushes
- Acrylic or India inks
- Light wooden surface
- Liquid varnish or spray varnish (fixative)

(1) Purchase or cut a light wooden board, such as pine or birch, for your painting surface.

(2) Wet the board using a round or soft brush.

(3) Dip your brush into the ink or apply the ink directly onto the board. Let it flow effortlessly onto the surface. You may wish to direct it some by pushing it around with the brush or by tipping the board. Let each layer of ink fully dry before adding the next layer.

(4) Add more colors and let them bleed in with one another. Think of the color wheel: Do you wish for high contrast? Analogous harmony?

(5) As each layer dries, you can keep building up the layers and make the painting as saturated as you would like.

(6) Wait until the painting is fully dry, and then seal it with a liquid or spray varnish.

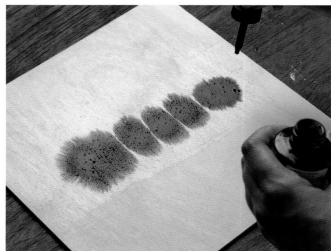

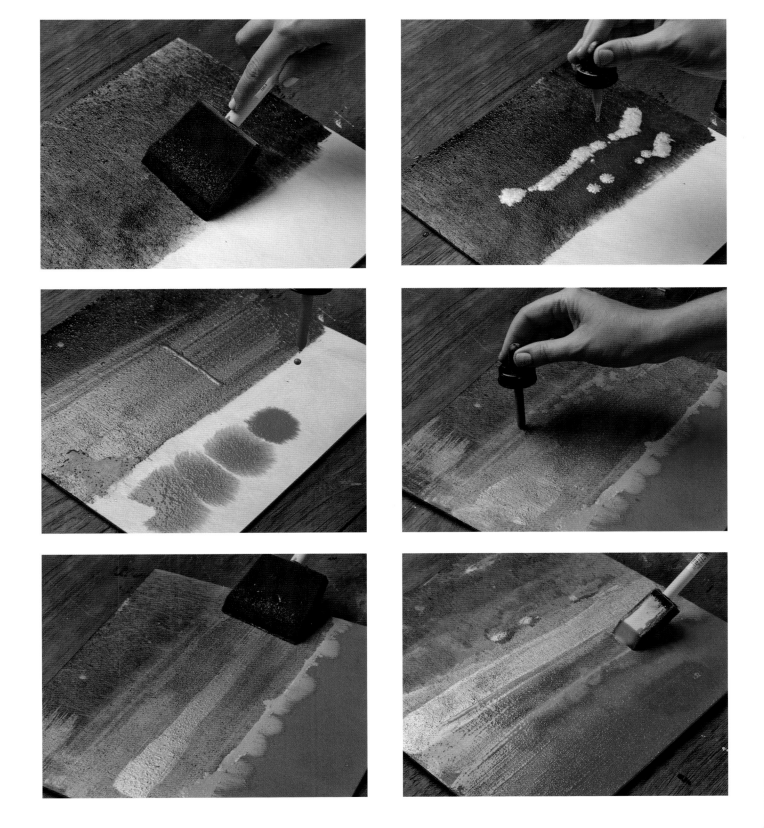

wash and drip

Try making a wash with water and watercolor or India ink. This is very similar to Let it Seep, but instead of wood, you'll use a surface like a clay- or gesso-coated hardboard (see page 16). It will maintain the purity and vibrancy of water-based media, and won't shrink or wrinkle when it gets wet. First, wet the surface of the board with water, then drop ink or dabs of watercolor (directly from the bottle or tube) onto the board. Continue to move the paint around with more water, or just allow the paint to travel as far as the water has spread. The latter works especially well with ink, because the pigment will only travel as far as the water has been laid on the board, which can create interesting effects when you layer the ink and add another color. Effective use of wash and drip creates fluid backgrounds and a sense of movement, and it can really help you to develop your painting intuition.

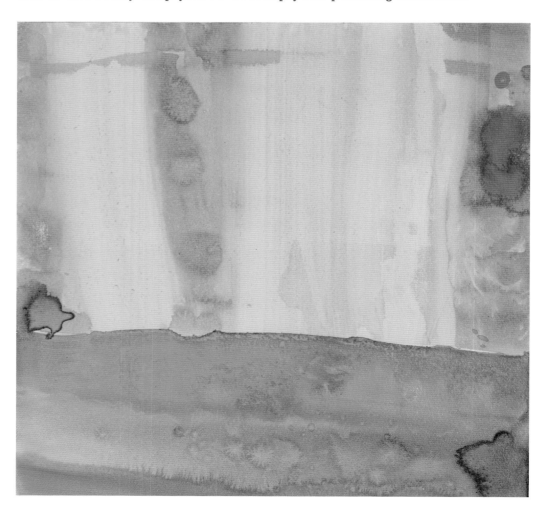

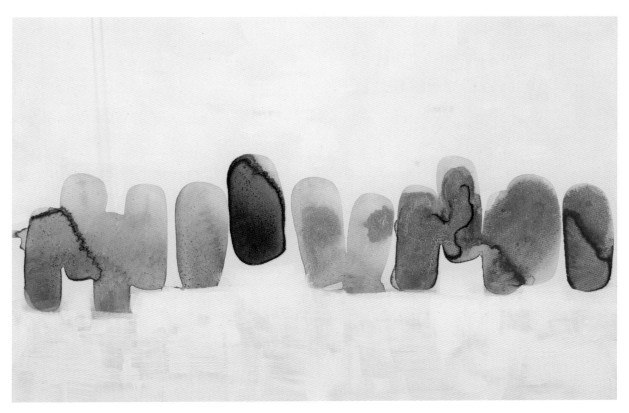

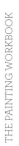

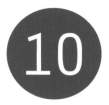

movement

Movement: an essential part of life, and a principle of art. Making movement a primary focus in a work of art can make it a dynamic piece where the viewer's eye is free to travel through brush strokes, color changes, and other elements. Create movement in a painting using strokes or lines, repeating shapes or impressions, and so forth. Here, we as artists get to direct the viewer on how to take in the work and thus create a specific feeling or energy. Movement can also be exaggerated or have a feeling of fantasy. Think of Van Gogh's *The Starry Night* and how dynamic the sky feels, with the brush strokes dancing around each star.

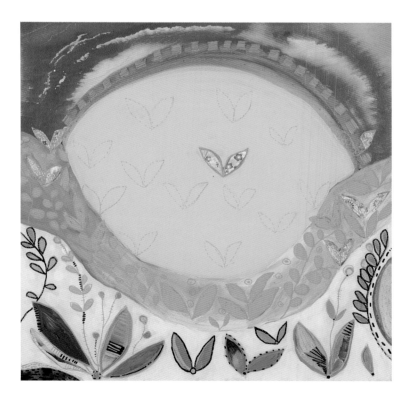

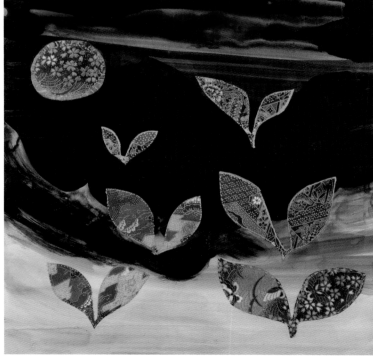

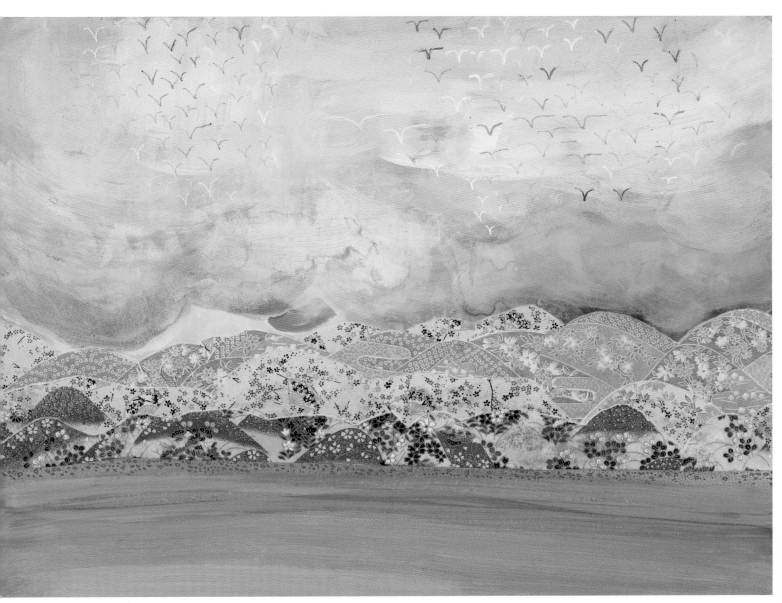

pattern play

Placing unique patterns against a painted color is a fun and crafty technique you can include in your process. Start by painting your background with acrylic paint. You can do a simple landscape horizon as seen here, or simple blocks of color. Then, use the layering technique (page 56), cutting out shapes or subjects from patterned or decorative papers. Instead of free-handed cutting, you may want to draw out your shapes in pencil first. Match up unusual and bold patterns and colors together to make a statement. Apply a thin coat of varnish both under and on top of the paper shapes, with a final coat of varnish at the end.

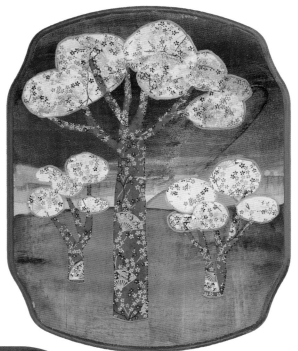

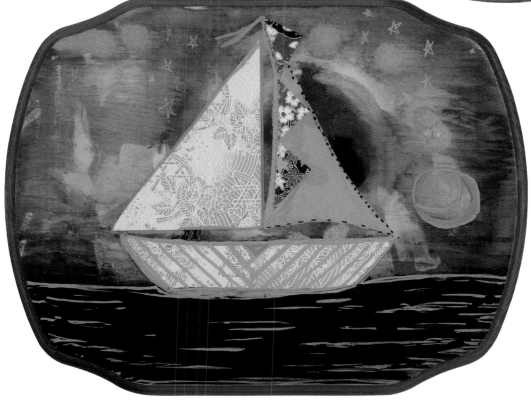

mirror-mirror

Reflecting subject matter can create a gorgeous symmetry or a feeling of balance. The subject can be mirrored side-by-side, up and down, or repeated throughout a piece. I enjoy this concept because it reflects to me the nature of life, or to quote Anaïs Nin, "We don't see things as they are, we see them as we are."

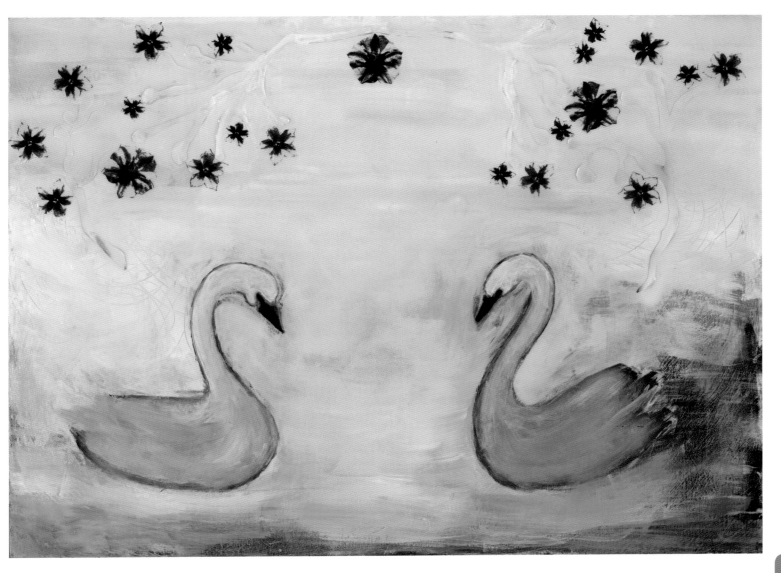

repetition

Rhythm is a vital principle in art. Repeating lines, shapes, colors, or forms in a painting provide a sense of rhythm, and it can be a meditative experience for the artist. In these paintings, I repeated marks using either a paint pen or ink, which allowed me to create more detailed patterns than I could with a paintbrush. Changing and breaking up these patterns l like I've done can lend contrast and create movement. You might even make or buy a rubber stamp to create your repeating shapes, or use an object as a stamp, like a nail, a puzzle piece, or a fork, for example. Repetition also does not need to be a central focus—it's just as effective if you only make hints of it here and there.

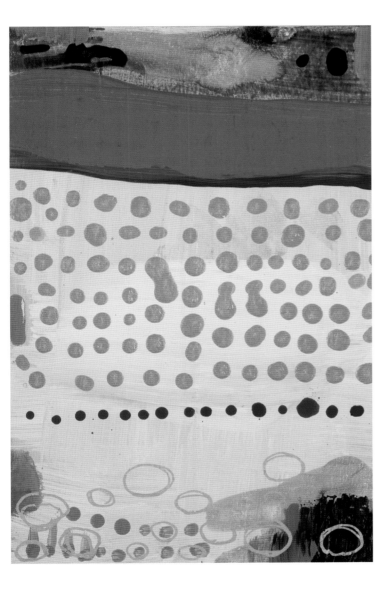

script

Drawing or painting text into a painting can be such a delightful way to add a meaningful touch to your work. Including a word or a simple phrase adds some depth in the form of personal narrative. Do this by using a paint pen or watercolor pencil as seen in the Draw On Top (page 70) or Draw Into (page 72) exercises. You want the words to be a natural part of the painting, so put them in a place where they fit, or where they even connect parts of the painting. Applying a spray varnish will seal your script in place.

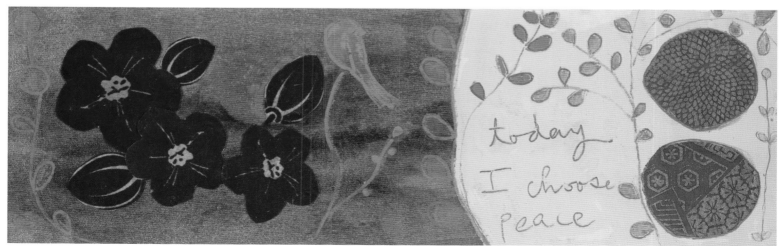

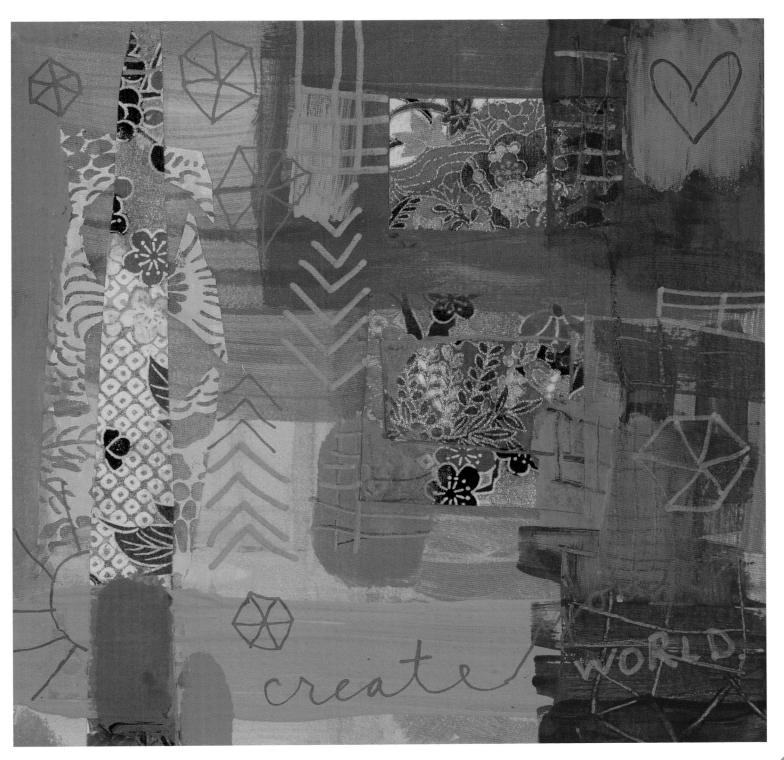

create WORLD.

layering

Artists who wish to go into a deep or intuitive process of painting, or simply like to spend a good amount of time with each piece, might want to try layering. Adding layers and layers of paint can create a unique depth and invite the viewer to spend more time gazing. Along with ink and acrylic, I also like to use paper, water-based paint pen, and other media to create my layered work. The paper can be applied using a clean, flat brush and thin coats of liquid varnish (matte or glossy), both under and on top of the paint. You can then seal the painting with an entire coat of varnish at the end using a flat brush or spray.

Mini-Workshop to follow

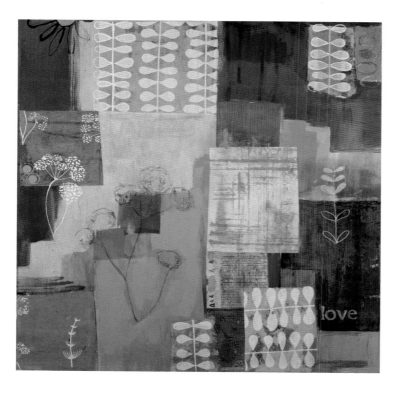

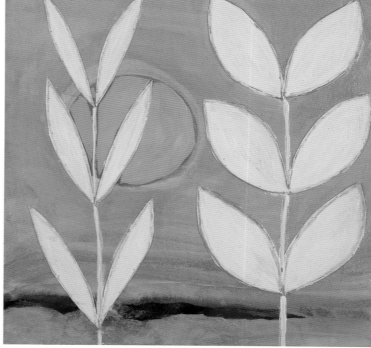

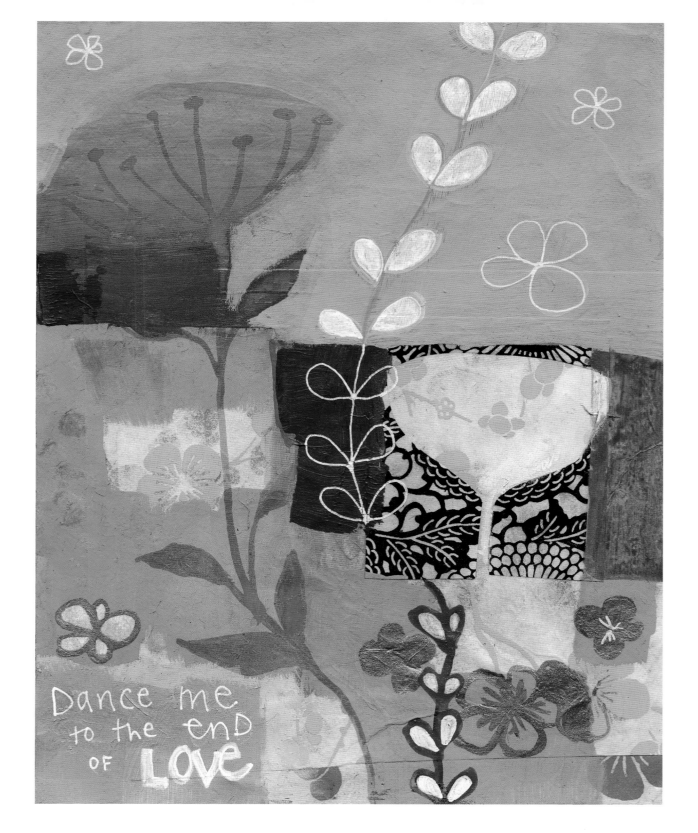

Dance me to the end of LOVE

Layering
Mini-Workshop

you will need

- Painting surface of your choice
- Acrylic paint
- Acrylic or India inks (optional)
- A variety of brushes
- Decorative paper
- Gel medium
- Water-based paint pens
- Liquid varnish or spray varnish (fixative)

① Gesso the surface or paint it using ink or acrylic paint. Paint in blocks of color or in a more fluid motion, depending on the style or aesthetic you want to convey.

② Continue to add more layers of paint until you have built up a rich background.

③ When the work is fully dry, begin to add pieces of paper, or cut out shapes from a variety of decorative paper. For example, I love working with eco-paper from Nepal, as well as origami paper.

④ Add a clear layer of gel medium with a flat brush onto the surface below the area in which you would like to add the paper. You can also add it directly to the back of the cut-out paper.

⑤ Place the cut-out paper onto the surface delicately so that all sides are where you want them. Press firmly and smooth it out with your hands to get rid of any air bubbles.

⑥ Varnish the top of the paper.

⑦ Continue to layer between all these steps as you like. Maybe you want to add more acrylic paint, ink, or details with paint pens. When the work is complete and totally dry, add a final sealant with varnish to protect the painting.

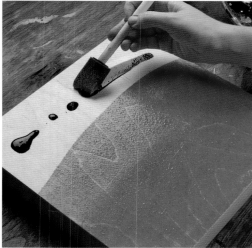

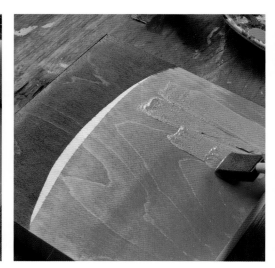

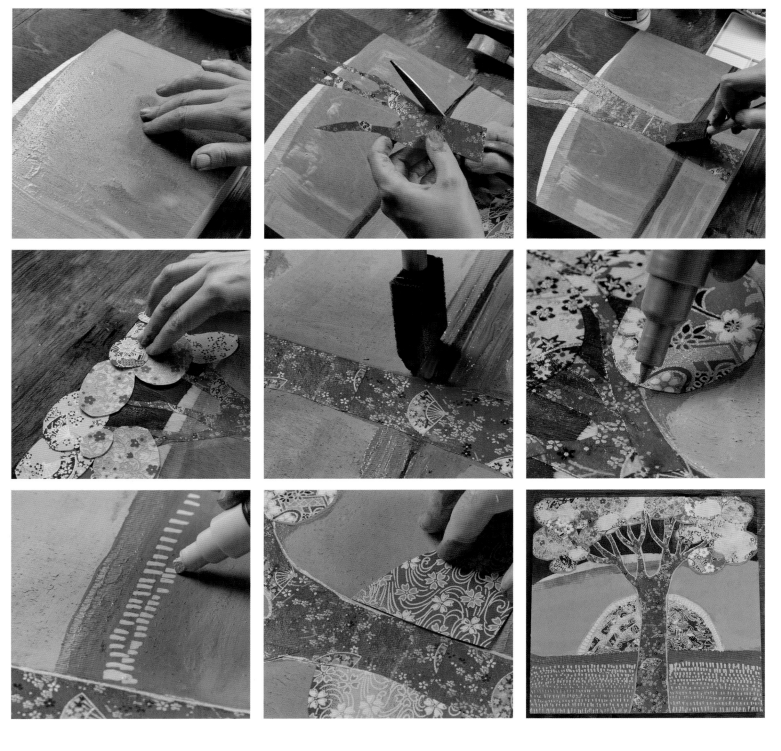

shape wonder

Explore all kinds of shapes in your work, such as circles, flowers, hearts, teardrops, and more. Experiment with stamps and stencils. Give the shapes the purpose of being something, plus create repetition or a feeling of movement. A helpful way to define a shape is to outline it with a paint marker. Be playful! Creating shapes can bring us back to more innocent stages of art making.

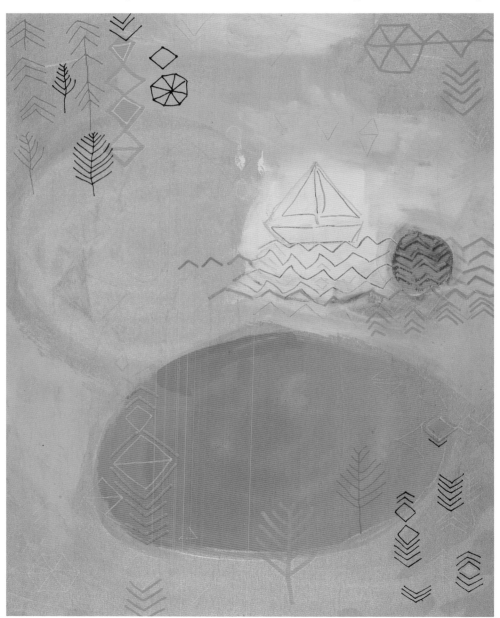

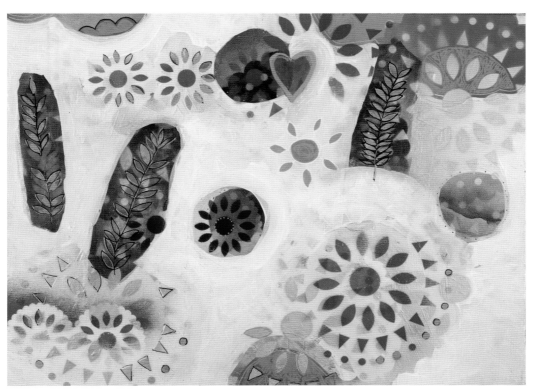

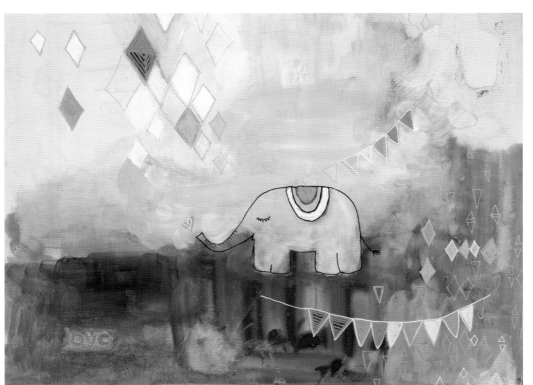

working in circles

As proven in Da Vinci's *Vitruvian Man*, the circle is as foundational to man as it is to the rest of the natural world. In art, its shape represents a perfect union, and it imparts principles of unity and harmony. You can easily incorporate the sun, moon, and other iconic expressions of circles in your paintings. I love starting a work with a circle and then building from there.

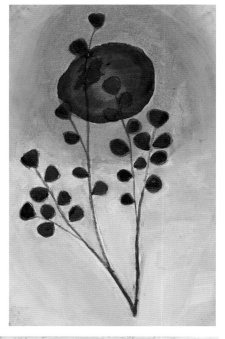

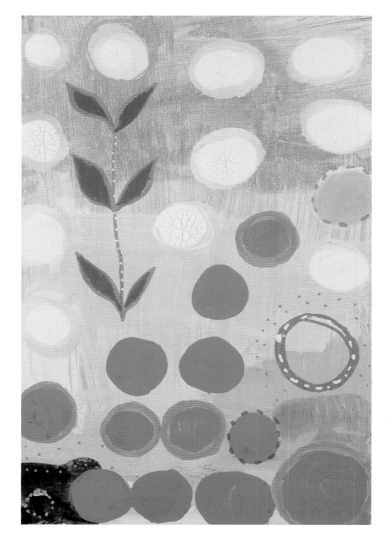

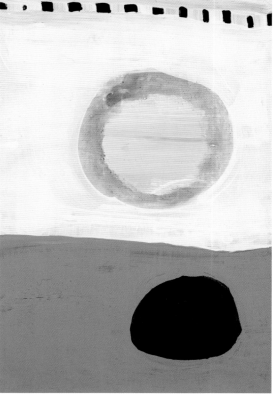

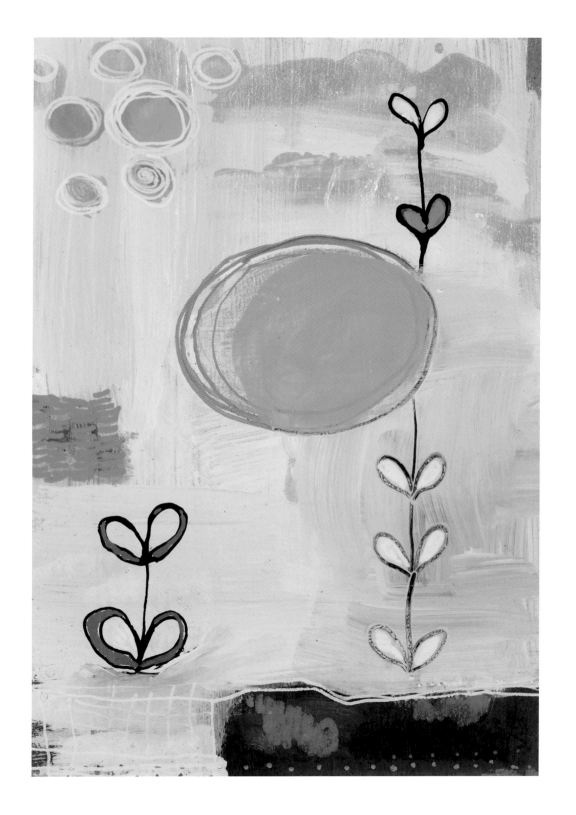

18 straight edges

Working in straight lines and shapes creates a more angular work and can add a nice contrast to organic shapes underneath or side-by-side. There are infinite ways to combine angular shapes and lines. An angular work will often have a contemporary or modern feel.

19 linear view

Like the circle, the line is a founding element of art. Mainly focusing on lines when you're painting creates a simple but bold point of view, and you can explore it in a variety of ways. For example, if you paint a certain subject, such as a tree or leaf, try using just lines to express its form. Using lines repeatedly creates rhythm and harmony, and it's also an excellent opportunity to explore the way groups of color work together.

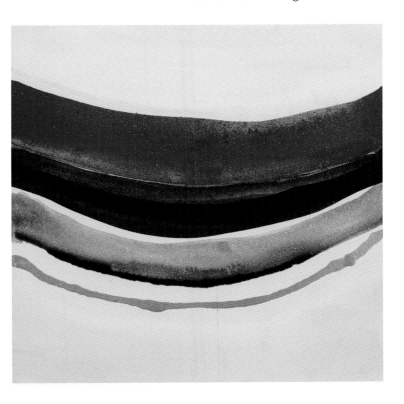

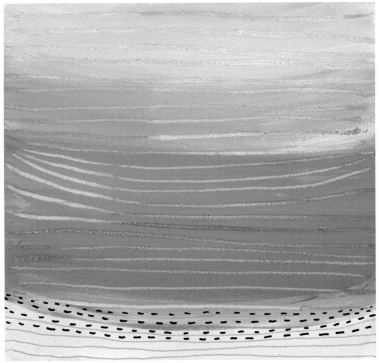

masking technique

Art media gives us the ability to paint in ways we wouldn't otherwise be able to. Masking fluid, for example, acts as a resist so you can paint over areas and then remove the dried fluid, revealing the paper underneath and leaving precisely defined unpainted areas on an otherwise painted surface. There are a lot of possibilities here to explore using this magical tool! Masking is great technique to try when you're working with watercolor or ink. *Mini-Workshop to follow*

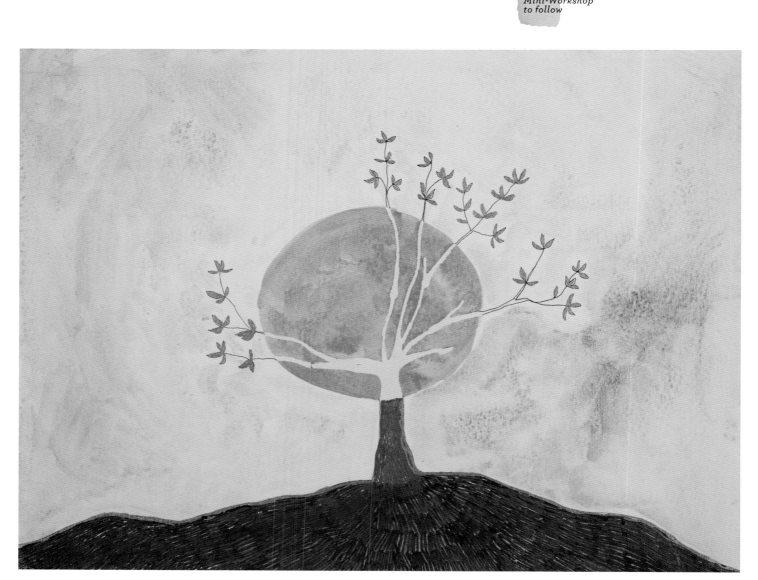

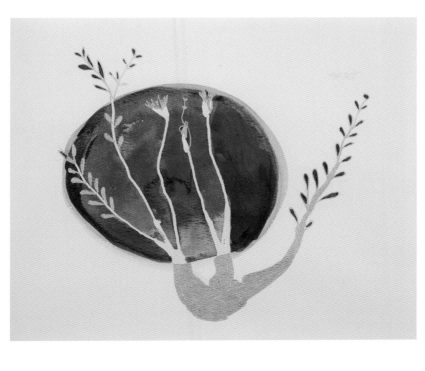

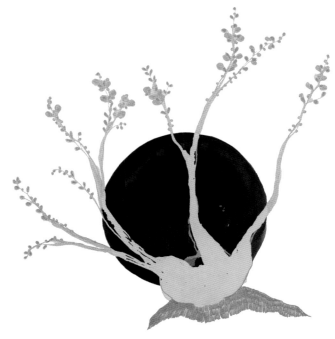

Masking Technique
Mini-Workshop

you will need

- Watercolor paper
- Watercolor paints
- Brushes
- Masking fluid
- Rubber cement pick-up
- Acrylic or India inks (optional)
- Paint pens for details
- Pencil
- White eraser

① Sketch out your idea lightly with pencil onto watercolor paper first. Draw with the masking fluid onto areas where you *do not* want the paint to flow.

② Once the masking fluid is fully dry, you may begin to paint with watercolors and ink. Make sure to clean the brushes off right away if you used them to apply the masking fluid.

③ When the paint is fully dry, you can remove the masking fluid by peeling it or by picking it up with the rubber cement.

④ Add details with the paint pens to finish. I have found that an extra-fine point is best when working on paper.

⑤ You also may repeat steps 1–3 as much as you like until you feel like the piece is finished.

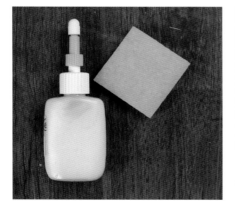
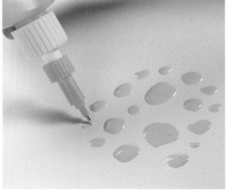
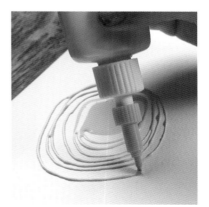

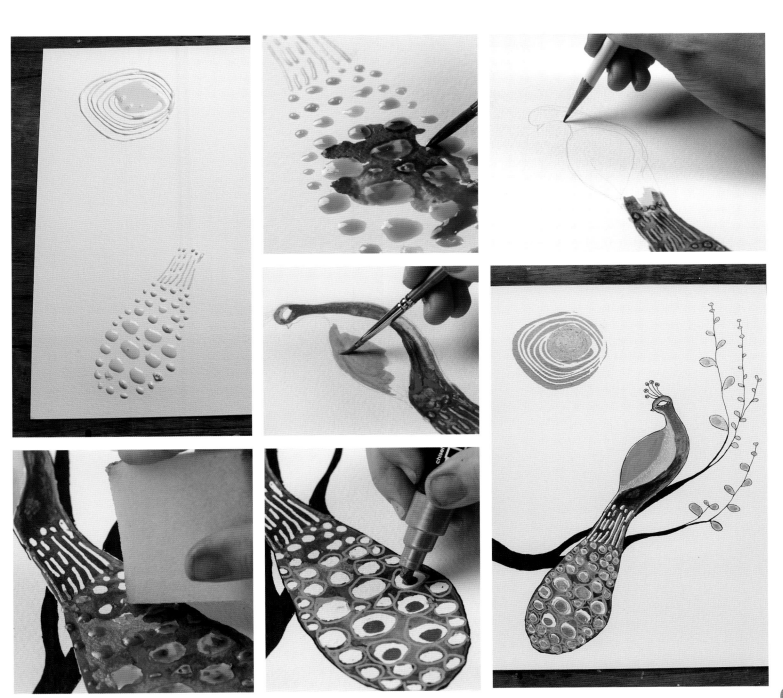

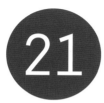

draw on top

A simple and precise way to add final details to a painting is by using water-based paint pens as a final layer. Once your painting is fully dry, take a pen or two and add outlines to shapes or other parts of your work you want to refine. I have found that this act of mark-making with the fine tip of a pen really brings elements of a piece together. It's also a great way to incorporate the arts of drawing and painting together in one piece.

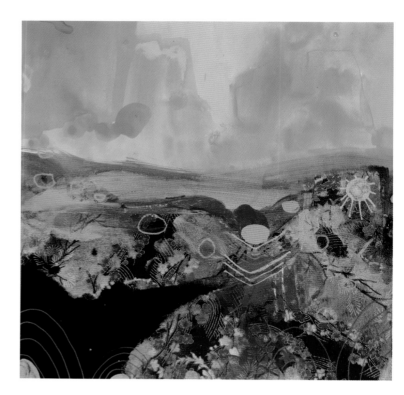

Breathe Deep.

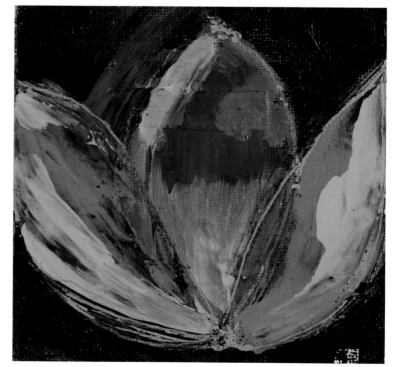

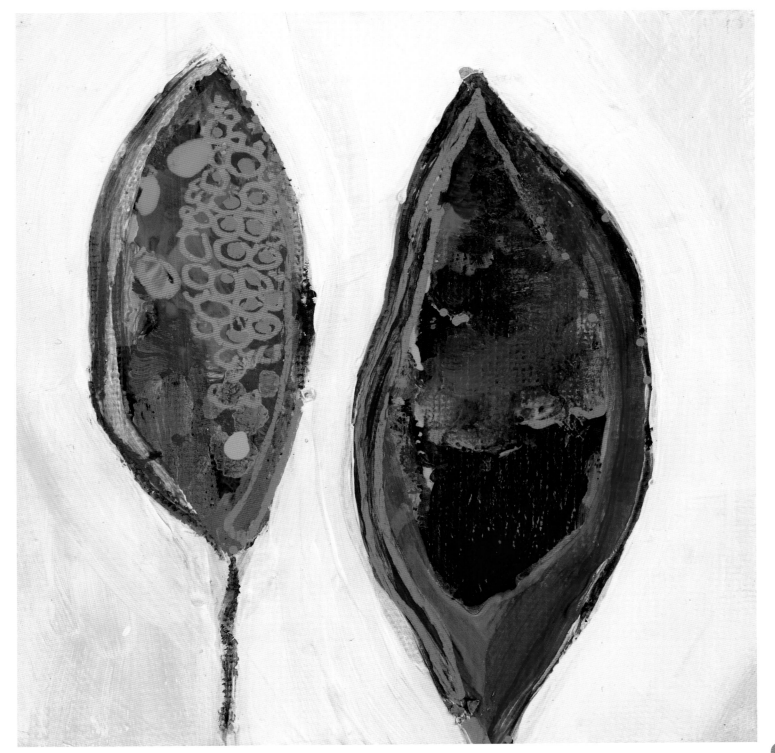

THE PAINTING WORKBOOK

22 draw into

A fun technique I discovered years ago is drawing into wet paint. I found that if I took watercolor pencils and drew directly into damp acrylic, the pigment would show up in an inconsistent and interesting way, and in places where the pencil failed, the layer of paint underneath would be exposed. The lines you make will appear as some combination of the underneath layer and the pigment of the pencil. The watercolor pencil also leaves an indentation, which imparts a wonderful sense of texture and depth. *Mini-Workshop to follow*

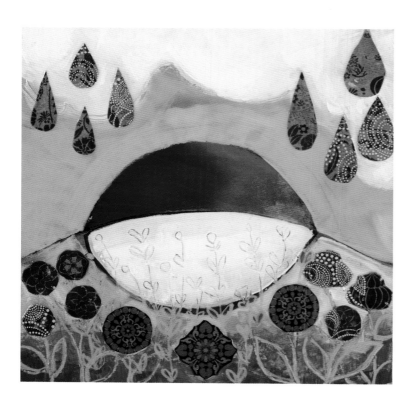

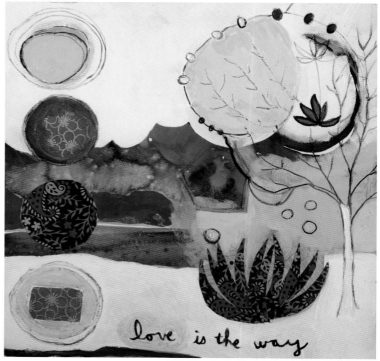

Draw Into
Mini-Workshop

you will need

- Painting surface of your choice
- Brushes
- Acrylic paint
- Acrylic ink or India inks (optional)
- Watercolor pencils
- Spray varnish (or fixative)

① Layer acrylic paint onto your surface and let it dry completely. You can even use India ink on the bottom layer if you prefer.

② Apply acrylic paint on top of that layer, and while it is still wet, take your watercolor pencil and draw directly on the painting surface.

③ Wait until the painting is fully dry, and then seal it by spraying a clear varnish or fixative on it to protect the soft watercolor pencil.

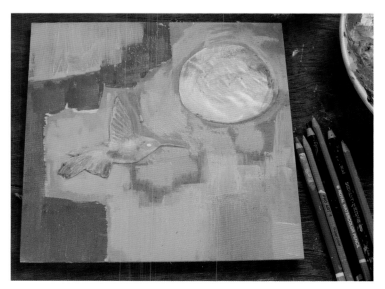

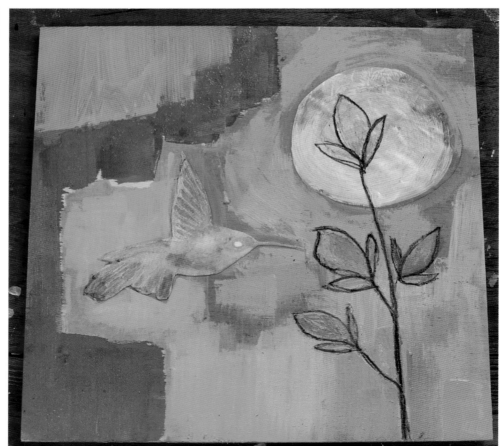

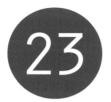

23 found objects

For quite some time now, artists have had the luxury of placing man-made objects into their work. Adding glass beads, marbles, buttons, and other similar items, as I have done here, is a unique way to add another dimension or layer to the painting process. Make sure to adhere these objects with a strong and durable adhesive or super glue and then coat it with epoxy resin.

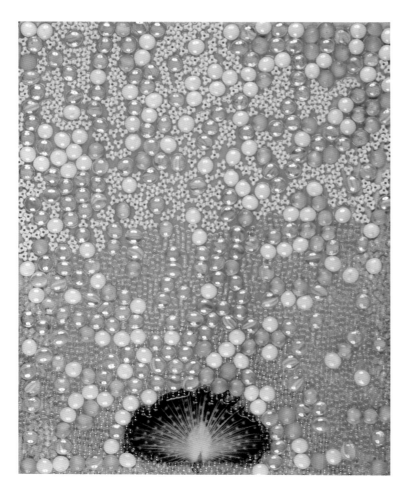

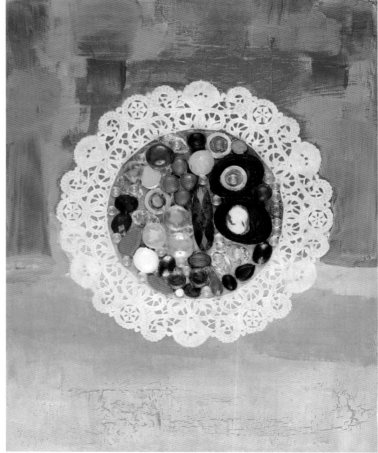

cardboard dreams

Yes, it is fun and possible to paint on cardboard, as well as economical! I have found that acrylic paint glides onto it with ease and adheres smoothly to all types of cardboard. This is also an easy way to experiment with new techniques or ideas without using up costly materials. You might keep some pieces of cardboard next to you while you work on a larger painting for that very purpose. And sometimes, those experimental paintings even become art that you'll want to keep. Spray or coat the work with a final layer of varnish to preserve it. I have actually seen paintings on cardboard in galleries in New York City, so don't rule it out as something to try!

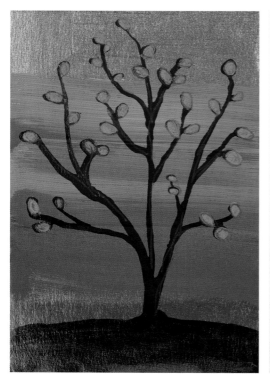
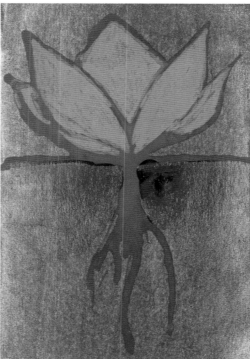
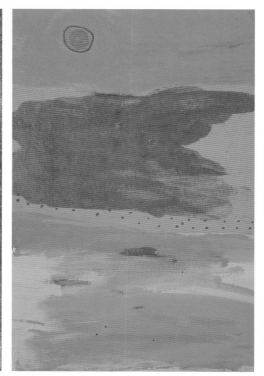

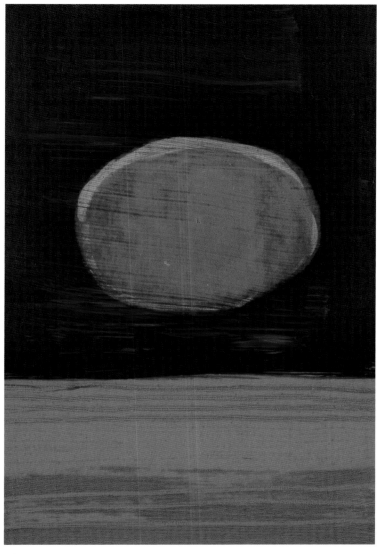

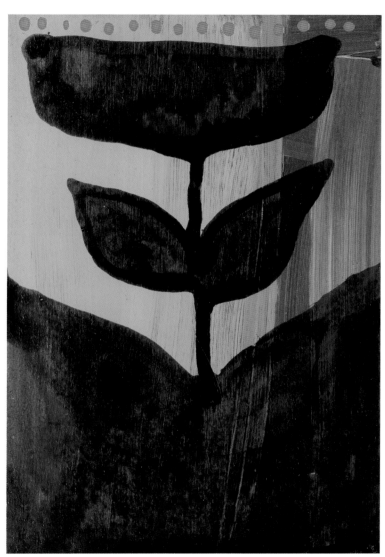

fabulous fabric

Give your work a real element of texture by adding fabric to it. Choose and cut into pieces a fabric that you like and then adhere the pieces to your painting with fabric or craft glue. Make sure to finish off the piece with a final coat of heavy or strong sealant so it'll be archival.

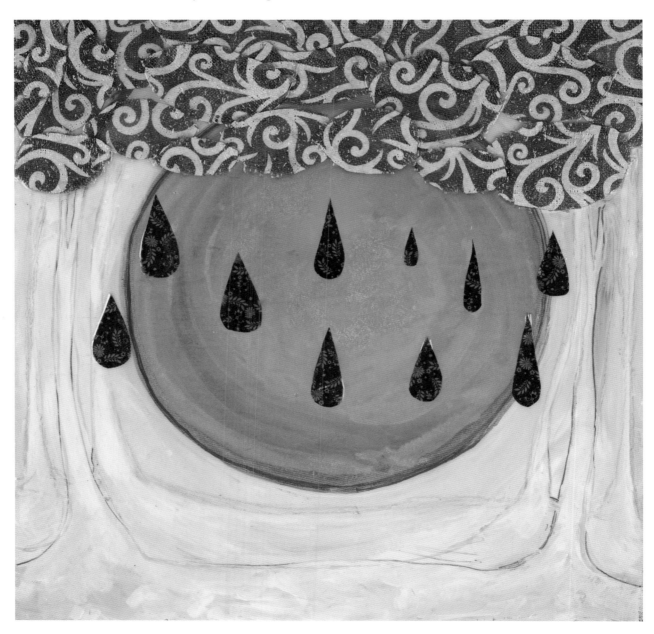

26 sparkle this

A playful way to add a little more depth and dynamism to your painting is by adding a very fine glitter to certain areas. When you are in the last stages of completing a work, sprinkle a dash of sparkle here and there. It's really amazing how just a little bit can go a long way, and how it can change the feeling of a work.

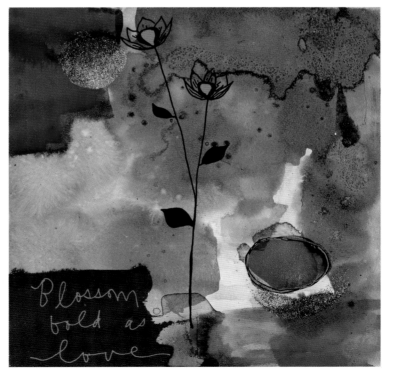

texture

Texture is of course one of the essential elements of art, so why not purposefully experiment with incorporating it into your painting? Texture can be either literal, such as adhering actual fabric, paper, or the like onto a canvas, or it can be implied through brushstroke, line movement, and color variation.

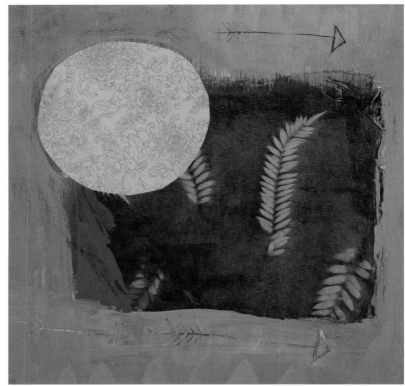

28 light impressions

In painting, we often work from personal experiences and our impressions of them, so why not make an impression of a real-life object? By applying paint directly to any distinctively shaped object, such as a feather, and pressing it onto the painting surface, we can give a work a pleasantly surprising element of reality. Soft things from nature are perfect tools for this, since they allow flexibility when being pressed or stamped onto a painting.

Mini-Workshop to follow

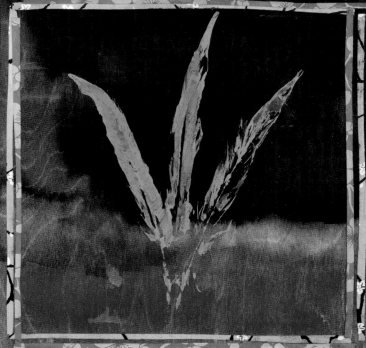

Light Impressions
Mini-Workshop

you will need

- Painting surface of your choice
- Acrylic paint
- Acrylic or India inks (optional)
- Brushes
- Feathers or similar natural, flexible materials
- Decorative paper (optional)
- Liquid varnish or spray varnish (fixative)

① Create and paint your background as you wish.

② Coat a real feather or other natural object with acrylic paint in a hue that contrasts with, or stands out from, the background. You may do this impression just once, or repeat it—it's up to you!

③ Add any finishing details and, if you'd like, a border of cut-out origami paper like I did (page 83).

④ As usual, when working with paper or other delicate materials, coat or seal the painting with a liquid or spray varnish.

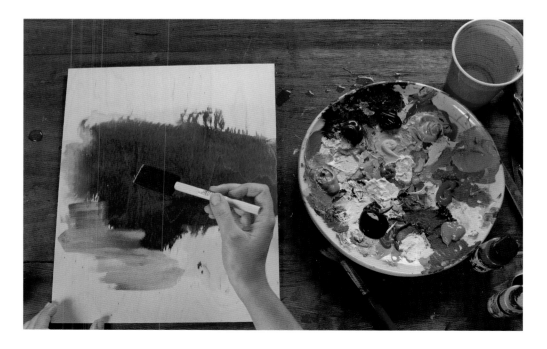

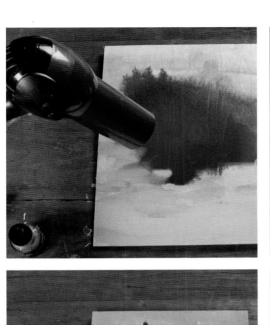
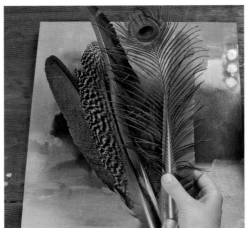
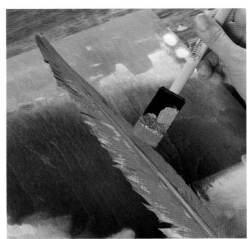
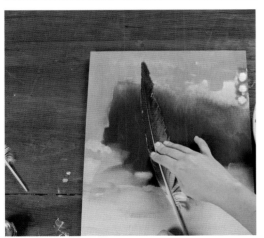
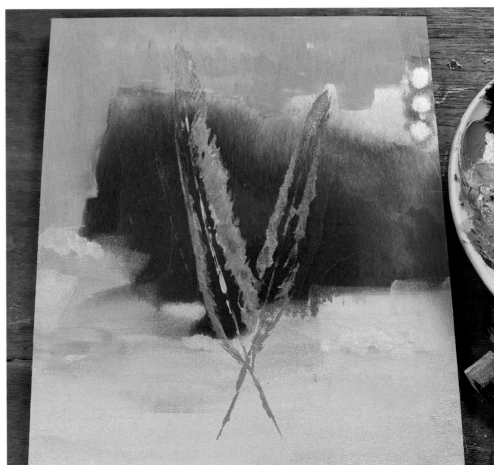
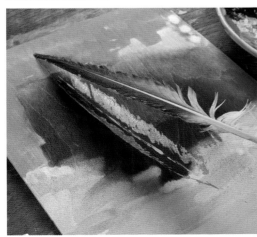

29 working with nature

Shells, stems, pressed or dried leaves, and flowers can add an exquisite earthy and three-dimensional quality to your work. Make sure to adhere them with a strong craft glue, and then seal it with a topcoat, resin, or varnish. Here, I used feathers and shells that I simply varnished onto the paintings (using a layer both underneath and on top). You can play off the shapes of the natural materials and build the work around them, making them central to the painting, or you can weave them into the painting to provide subtle hints at nature.

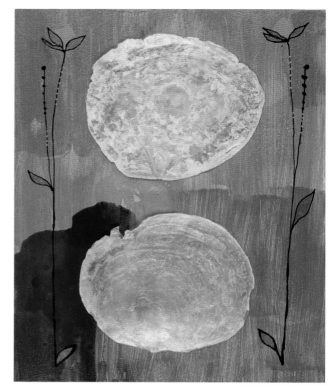

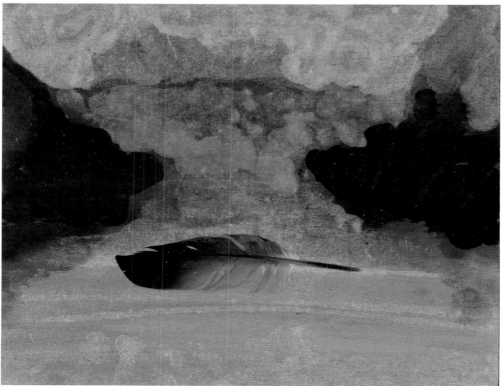

into the woods

The forest and the trees that inhabit it can be expressed in a variety of ways, and have been for centuries by artists of every kind. Be bold or out-of-the-box when painting such thoroughly explored themes: Experiment with unusual color and perspective. Try for something new in this classic subject matter.

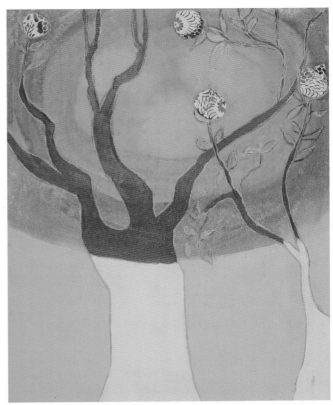

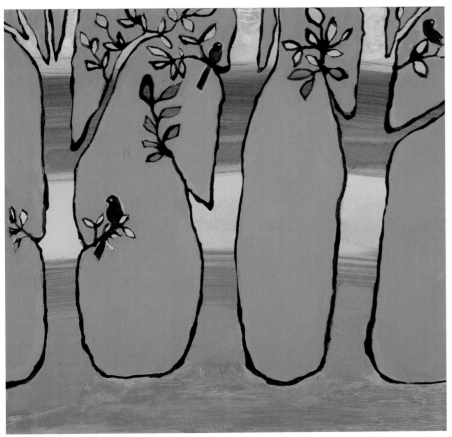

seasonal creation

Look to the seasons to find easy and natural inspirations for color, subject, and overall feeling. Start by painting the current season and let it unfold for you from there. What do winter, spring, summer, and fall evoke for you? How can you express each season through color, shape, subject, movement, and texture?

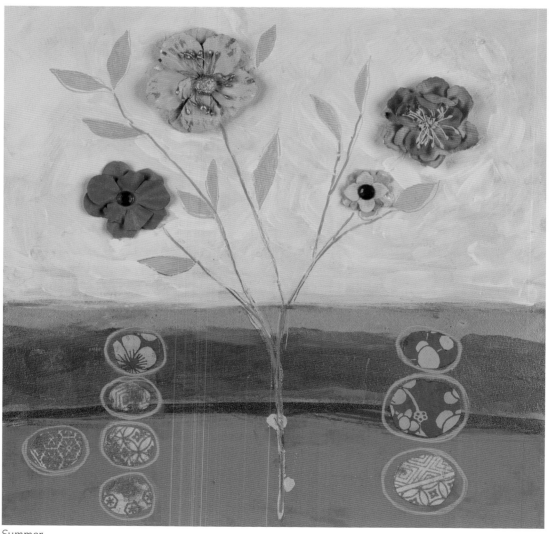

Summer

Spring

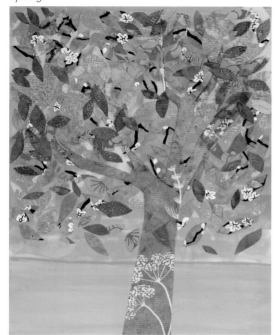

Fall

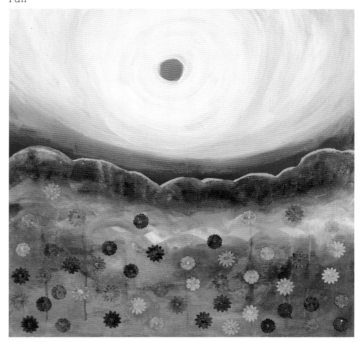

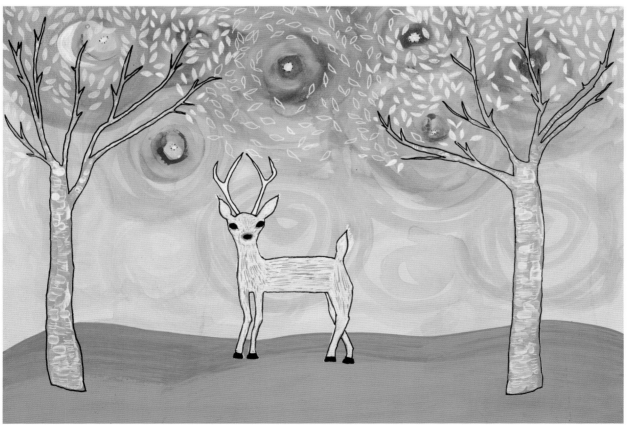

Winter

botanical muse

As far as what I am naturally drawn to as an artist, the botanical world never fails to allure. To me, the timelessness and perfection of natural shapes and silhouettes speak effortless beauty. Explore which botanical forms speak to you by researching them in a book or online and doing some sketching. Remember, practice makes better! Start simply and slowly, depicting one to three flowers. Don't overdo the color either—maybe three to six hues and shades.

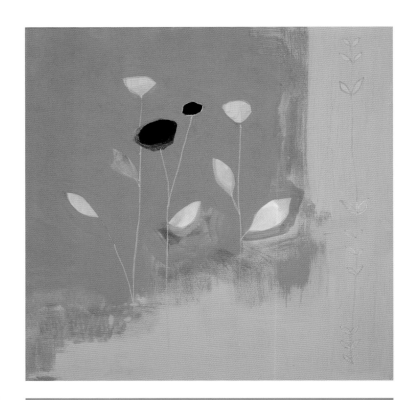

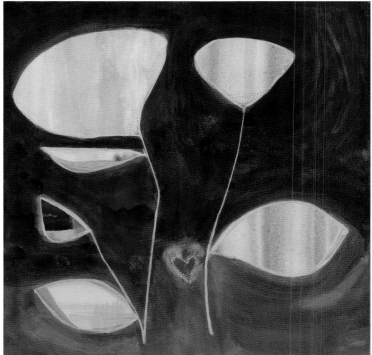

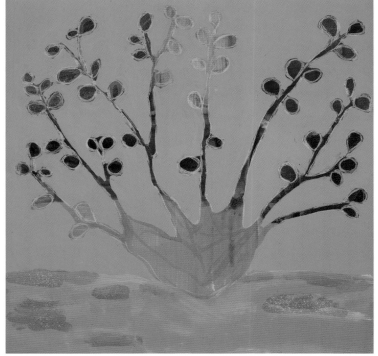

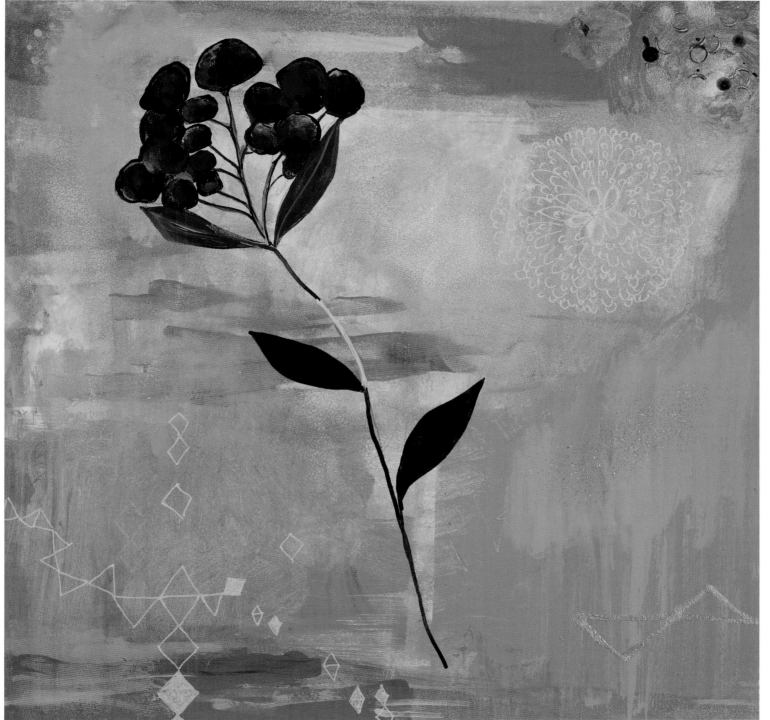

33 earth and sky

Land and clouds, moon and mountains, water and sunset: Paint your own version of the sky and earth with fluid layered colors and pattern. Again, try something different or unusual, like collaging origami paper as the sun's rays, or adding just a touch of glitter around the moon.

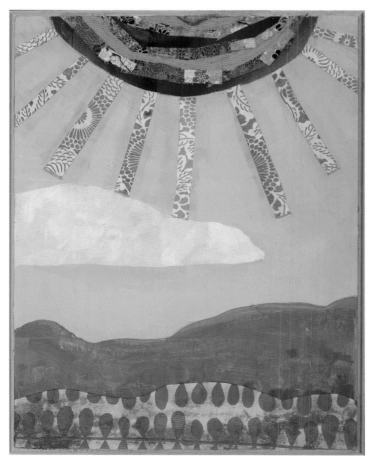

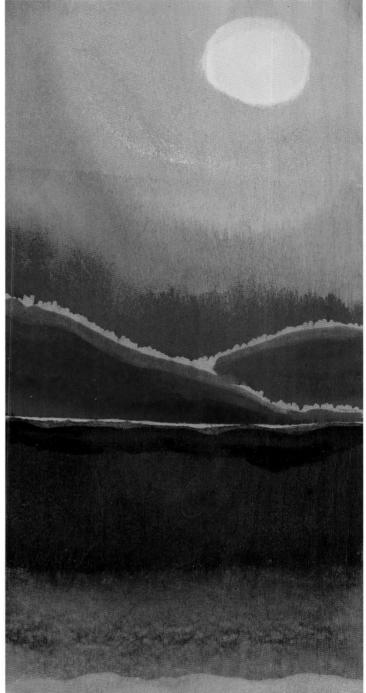

landscapes

Classic, modern, and contemporary paintings have always included the natural world as a subject matter. Whether they're simple or incredibly detailed and realistic, landscapes can be expressed in so many ways, depending on the personal aesthetic and style of the artist. It doesn't have to be a literal interpretation of a landscape either. There's a lot of room for abstractness and creative license.

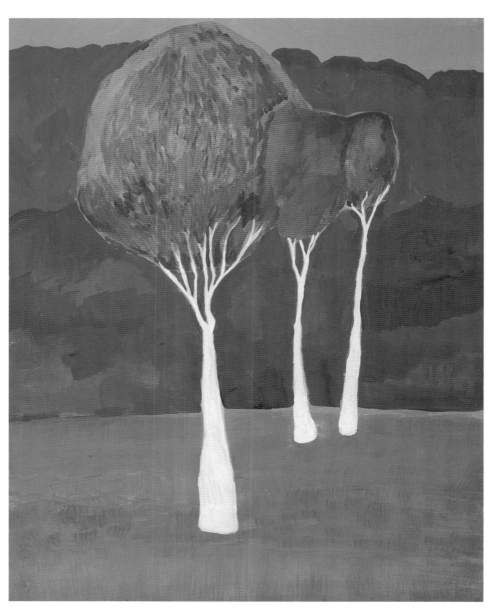

the sun

The sun is the center of our solar system, so it lends itself naturally to being the center of painting. Painting the sun is also a great opportunity to brighten up a piece and explore warm hues and golden tones.

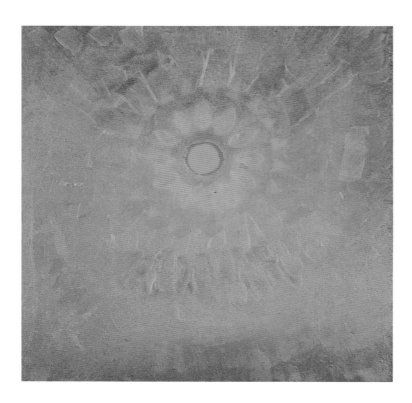

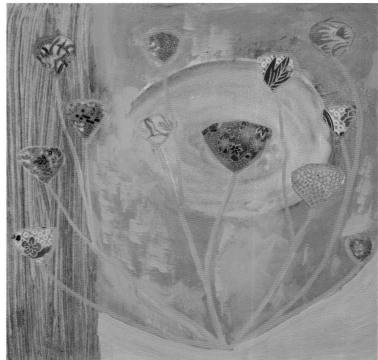

the moon

36 Many songs and poems have been devoted to this timeless subject, so why not works of art? Whether you paint it large or small, glowing white, or deep blue, a moon will add a dreamy depth to your work.

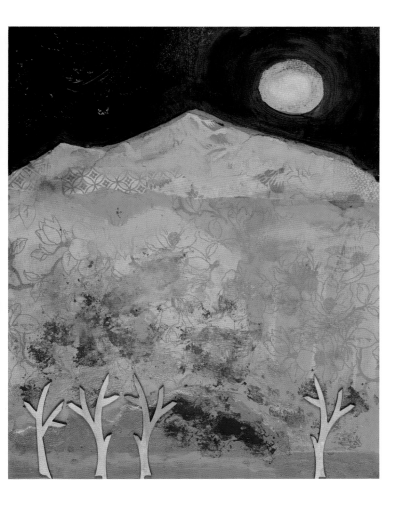

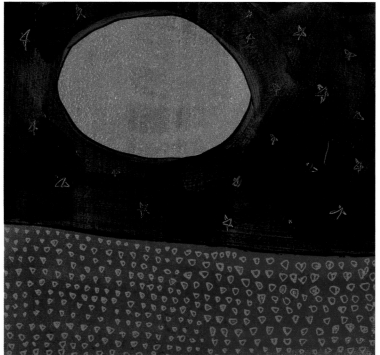

37 fauna

Exploring the animal kingdom as a main subject matter in painting is a delightful way to create a rich and playful narrative that is also beautiful. For example, the ever-popular bird is found in countless contemporary works. Think about other creatures you might like to use: rabbits, deer, foxes, elephants, squirrels, etc. In native texts and folklore, each animal comes with its own spirit, or characteristics, which might be something else to reflect on as you begin to work.

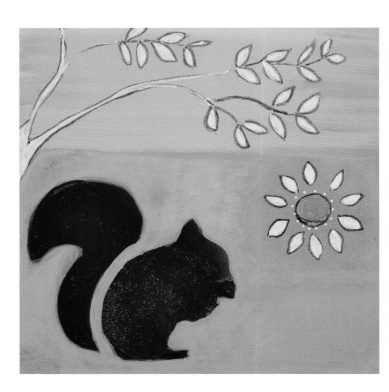

38 paint with prints

Using prints of your own work is a fun and fitting way to add a unique layer to your painting. It gives you an opportunity to combine and design old elements in new ways, and it can even inspire brand new ideas! Of course you can incorporate prints of anything into your paintings, but I love creating a multimedia piece that contains elements all of my own inspiration and effort. If you have any themes that appear again and again in your paintings, here is a wonderful way to reuse them without being repetitive.

Mini-Workshop to follow

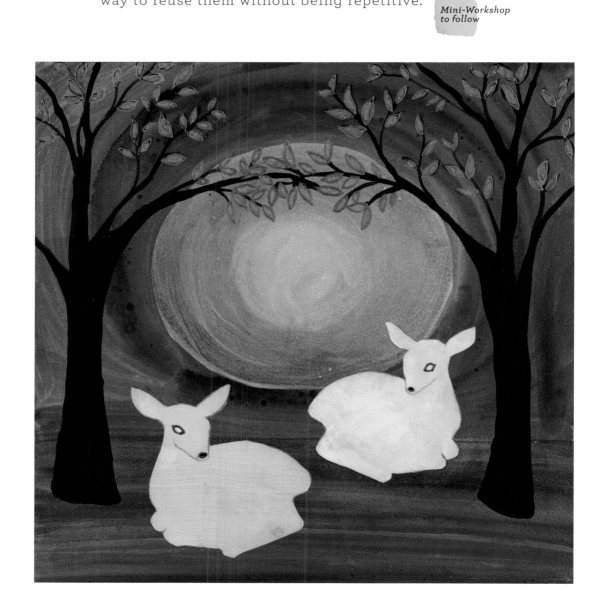

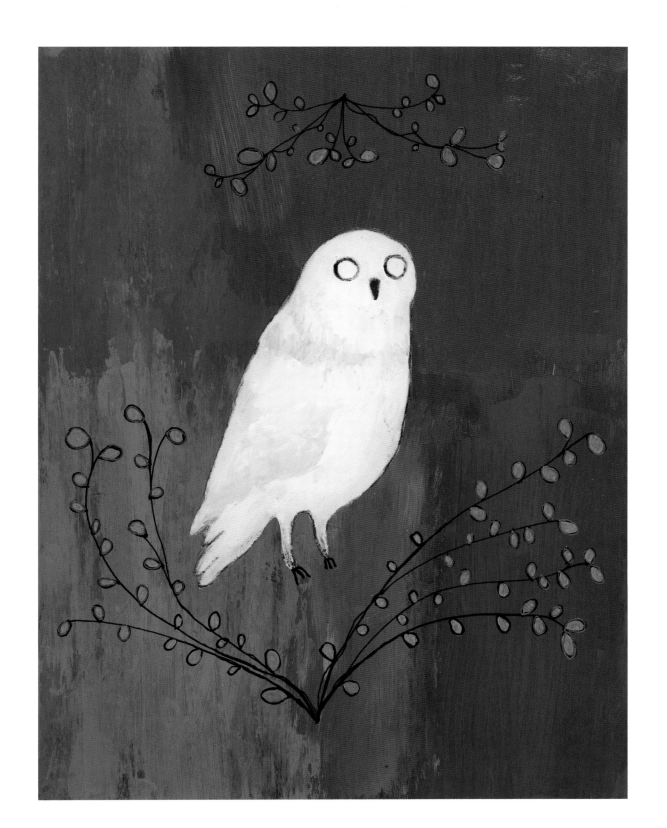

Paint with Prints
Mini-Workshop

you will need

- Painting surface of your choice
- Archival print(s) on matte paper
- Acrylic paint
- Acrylic or India inks (optional)
- Brushes
- Gel medium
- Liquid varnish or spray varnish (fixative)

① Scan your work and then print it out on an archival ink-jet printer. I like using thick cardstock paper.

② Cut out parts or simply place an entire print down using gel medium. As shown previously, make sure to take a flat brush and coat the medium below and above the print.

③ Paint the piece to your liking, and then seal it with a final coat of gel medium or clear varnish.

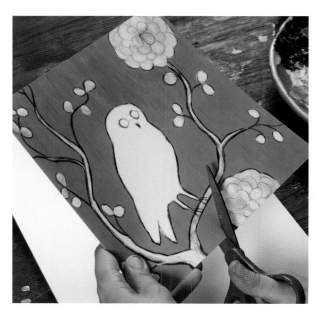

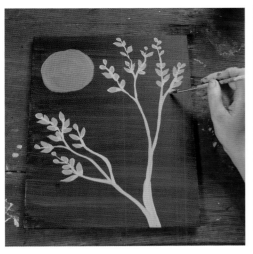
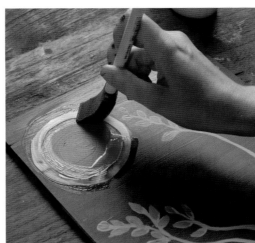
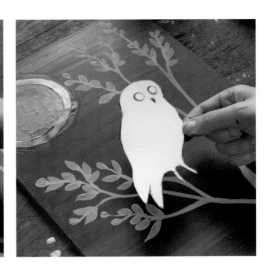
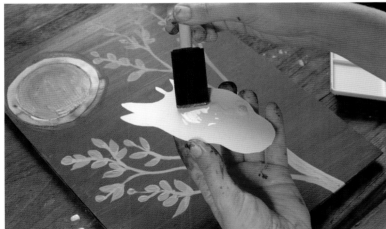
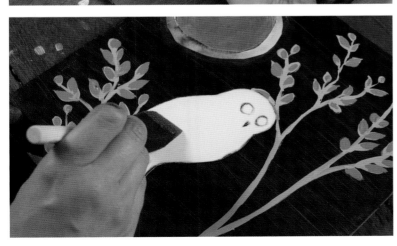
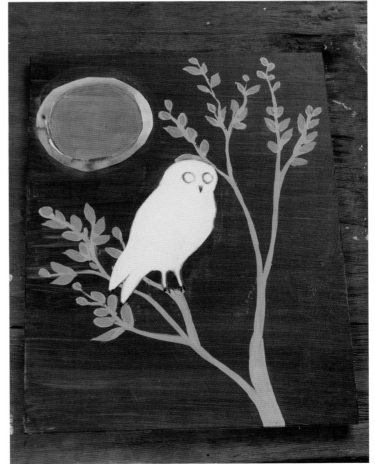

39 birds birds birds

With there being so many ways to portray such exquisite creatures, birds give artists an ideal subject matter, since they're timeless and can be placed in so many ways. Use birds as way to explore color, shapes, pattern, composition, and so forth. Try putting them in different settings and backgrounds. Use the subject of a bird as a way to experiment with your style and try new things.

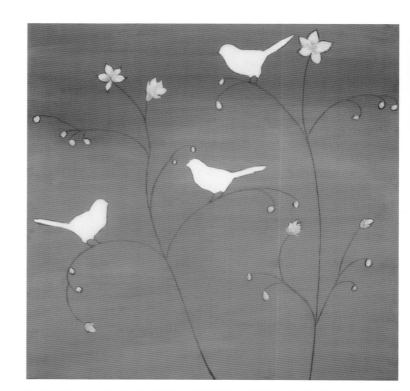

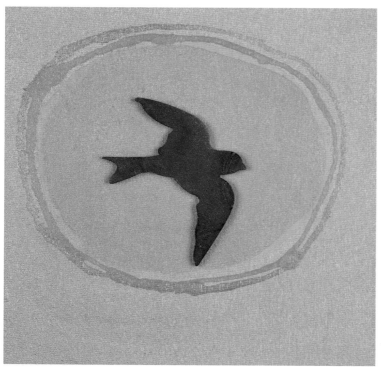

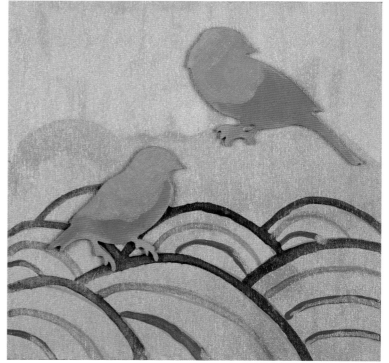

figure this

The human body is another timeless tradition that many artists have been drawn to expressing and exploring. Just like when you paint faces, you'll do this in your own unique style. You can also look to the masters to study the human figure and how they explored it. You might even choose to attempt a master copy in which you do your own artistic rendering of a master painter's famous piece.

41

about face

Painting the human face is a part of art history that I feel every painter should explore. Not every artist will make faces central to his or her work, and certainly, each of us will have our own unique way of expressing the human face that best suits our own style and technique. Take Picasso's paintings for example—his work clearly doesn't represent faces in any literal or classical sense, but they're still unmistakably faces. Practice drawing facial structure to get acquainted with it first. This will help you immensely as you prepare to do the painting itself. And, once you begin the painting, sketch the face with a pencil onto your painted background, then fill it in with paint.

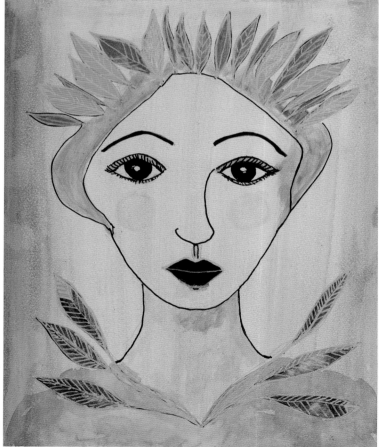

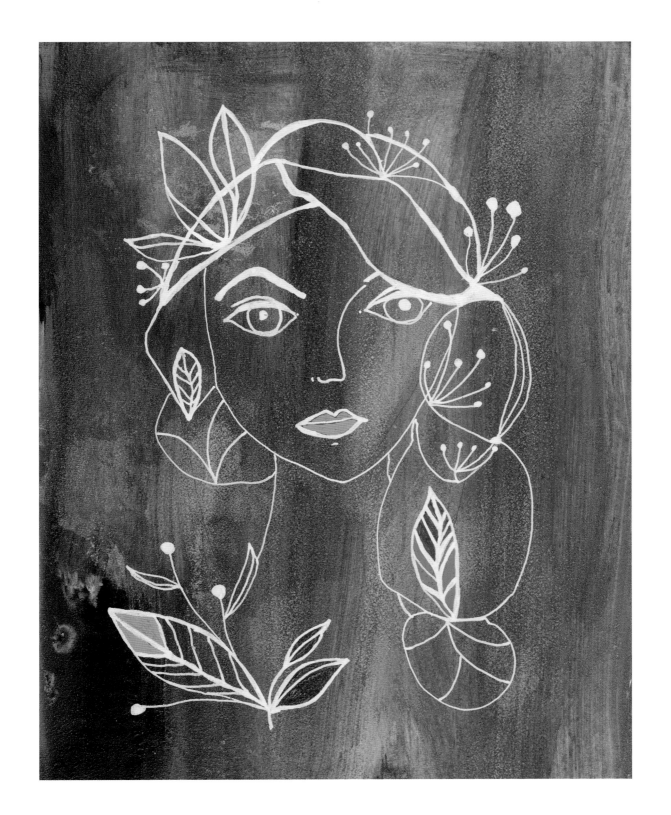

42 cityscapes

If an artist is to look to nature for inspiration in landscape painting, then an artist should also turn to a cityscape to notice the contrast and patterns of urbanism. There are many different ways to express the horizon of urban development; here I took a different and perhaps more colorful approach by using a variety of papers to represent the buildings.

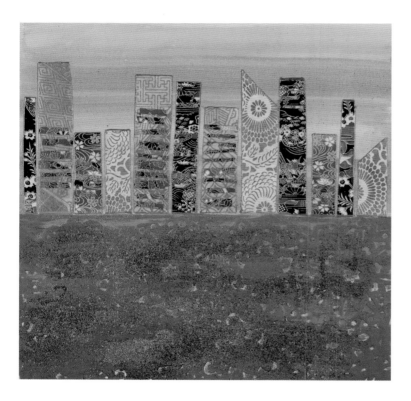

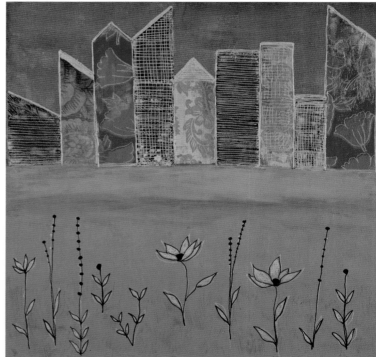

seascapes

It's no secret that I love to include sailboats and the sea in my painting. It's a subject that has long been an inspiration for artists, but that doesn't mean there aren't original ways to approach it. Sailboats offer a fun way to explore pattern and color, plus they can evoke a playful or nostalgic narrative.

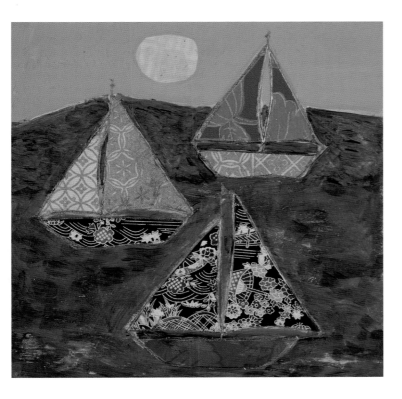

intuitive flow

Work in a total state of non-judgment to your own process and just allow yourself to create in a state-of-moment awareness, the way children often do. Add layers of paint, paper, and pen so that all of your strokes, applications, or marks dance and support one another. Release your need to know what it will look like in the end and instead allow each step to guide you to the next, so that each decision creates an intuitive roadmap of how to create. Add your final finishing details once the work feels complete.

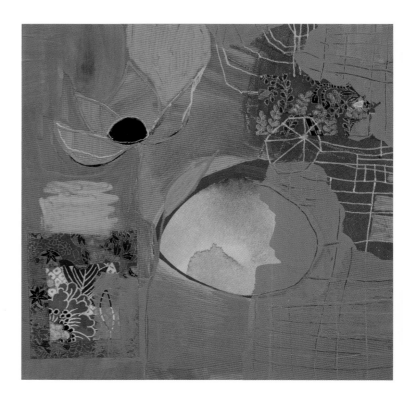

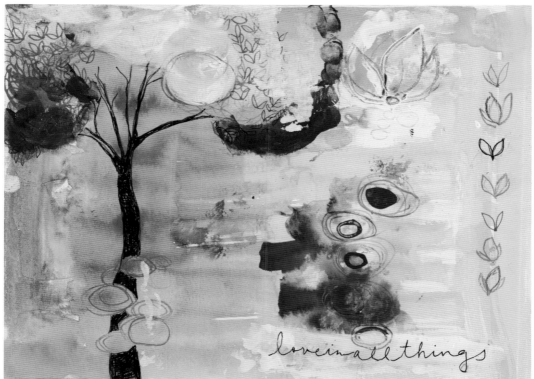

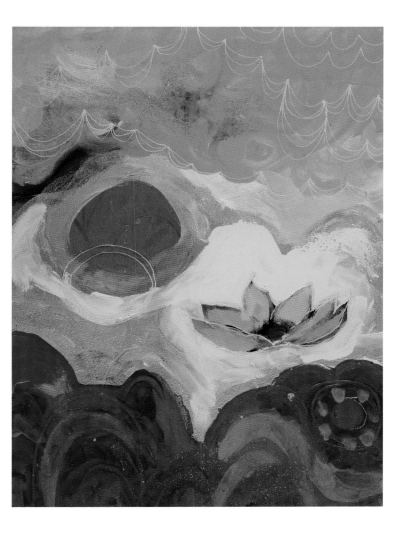

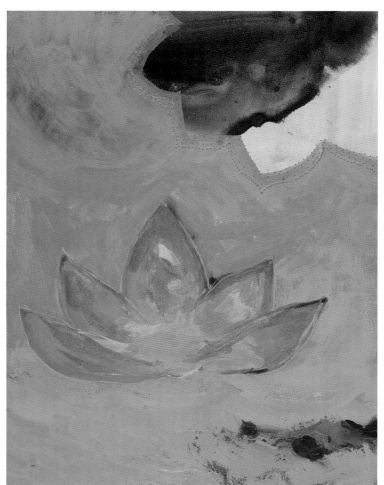

paper and paint

Throughout my years of painting, I have come to discover that paper and paint are very compatible. I enjoy this playful process immensely, and I encourage you to experiment with it as well, by layering paper and paint. The patterns in the paper you choose can inspire you to work off those colors with paint in either a complementary or contrasting color theme, highlighting, blending, and so forth. Dance between the two, use your fingers, tear paper, add ink on top of the paper, etc.

Mini-Workshop to follow

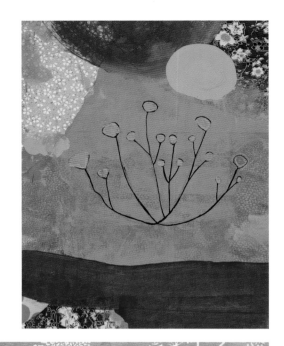

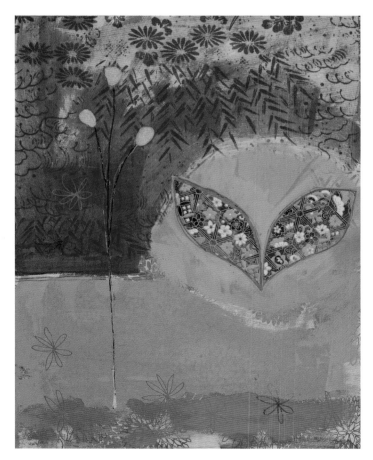

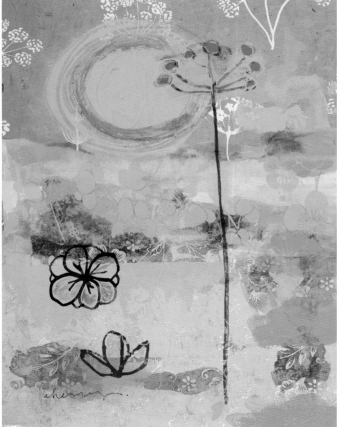

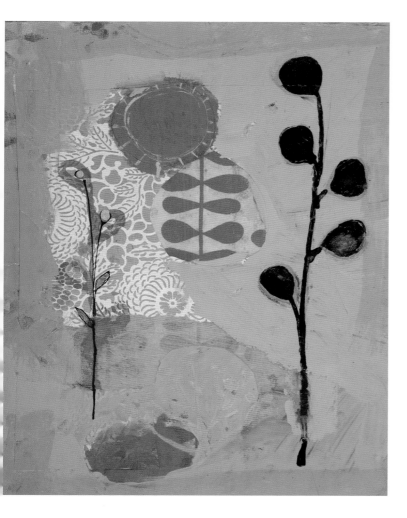

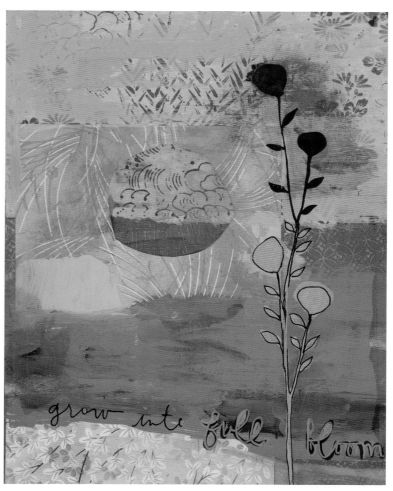

grow into full bloom

Paper and Paint
Mini-Workshop

you will need

- Canvas or panel (optional)
- A variety of decorative papers
- Brushes
- Acrylic paint
- Acrylic or India inks (optional)
- Water-based paint pens
- Scissors
- Gel medium or decoupage
- Liquid varnish or spray varnish (fixative)

① Start with a sturdy piece of archival or decorative paper, or a canvas or wooden panel. You may wish to adhere several torn or cut sheets of paper to build up the background and make it more rigid if you're only using paper. Adhere them together with a gel medium. Remember, gel medium can be applied using a flat brush below and on top of each layer of paper.

② Begin to layer with paint, then paper, more paint, and so on. Do this intuitively and freely. Use your hands if you'd like, interplay between the two. Cut out distinct shapes or tear the paper. Work with contrasts.

③ You can tie the final piece together by adding finishing touches with a paint pen.

④ Varnish the entire work when it's complete. If you're working with paper, which bends and wrinkles easily, it will be necessary to frame the piece.

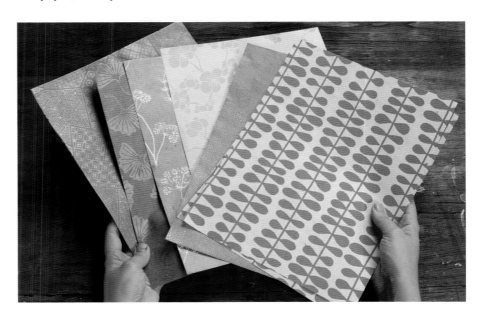

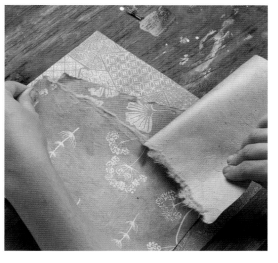
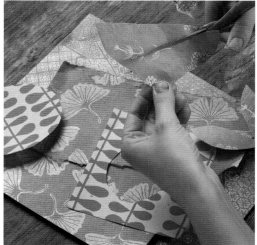
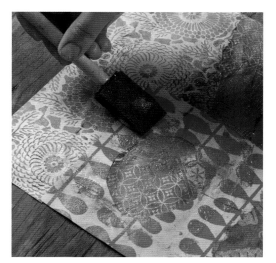
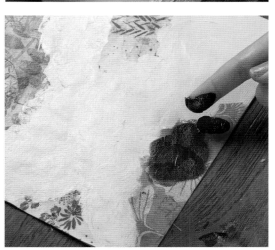
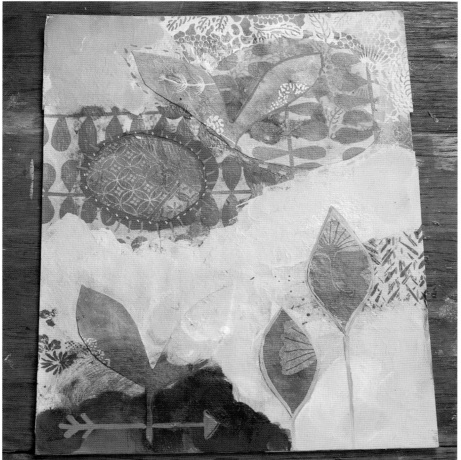
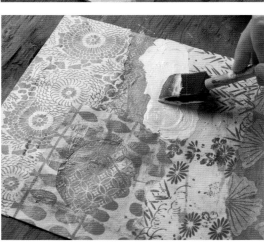

46

bless this mess

This exercise can be an even more liberating experience than the Intuitive Flow (page 110) method of working freely with standard design elements. Don't even consider the outcome of the painting, work completely from instinct, and make a mess! Think about that time you drew on the walls with your markers as a kid. Smear color with your fingers, drop ink onto the board, draw into wet areas freely with a watercolor pencil, and allow yourself to play! Even if you end up with a piece you want to throw away, it will not have been wasted time or materials—this kind of playing works your creativity muscles!

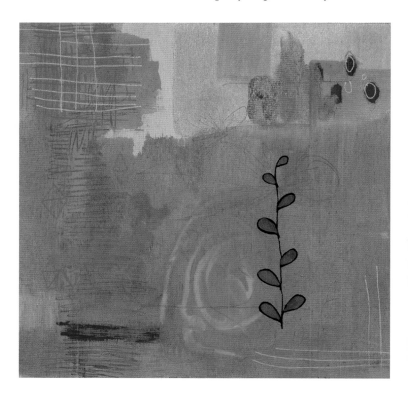

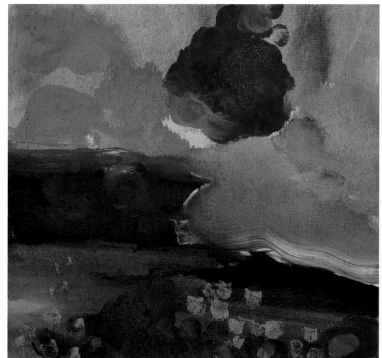

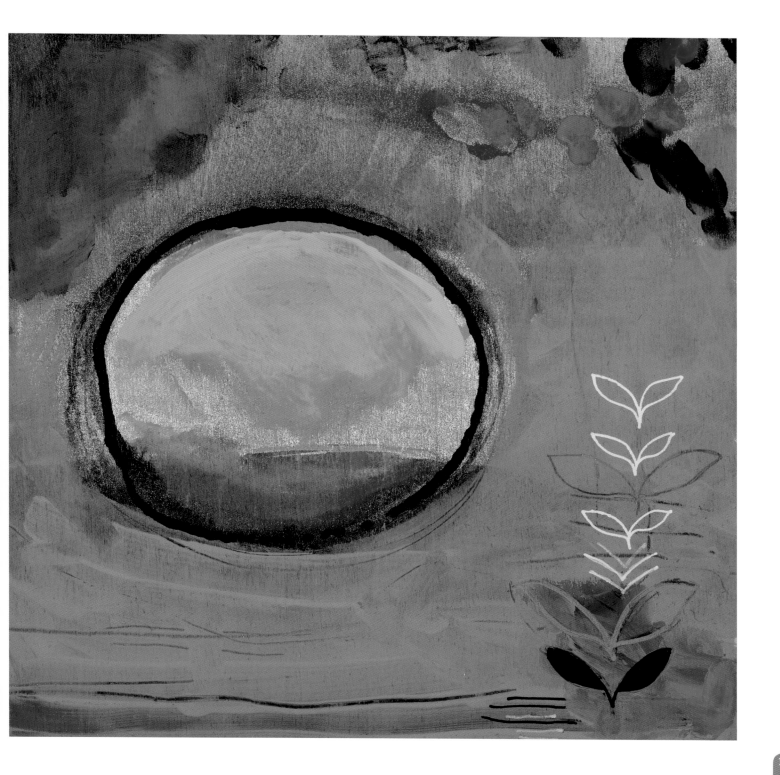

understated beauty

Less can be more, and keeping works in the range of peaceful and modest can actually create a lot of depth, movement, and perspective. If you are prone to making multi-colored and multi-layered works, attempt self-control by keeping color and subject matter to a minimum. Practice the art of restraint by keeping an overall quiet feeling, where each stroke or highlight is noticed. Find the beauty in soft lines and brushstrokes.

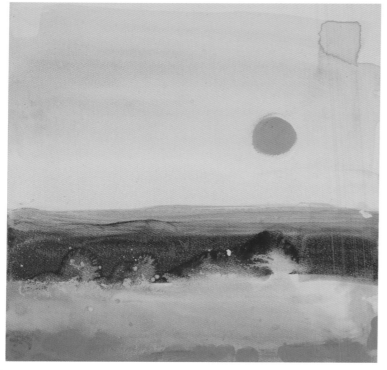

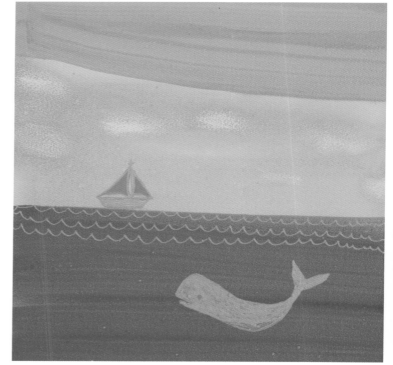

bold love

Experiment in painting by using neon and metallic colors, sparkle, bold marks and strokes, and combinations thereof to create a feeling of pop or modern art. Using text or images that clearly convey the idea of love ties the meaning of the work together.

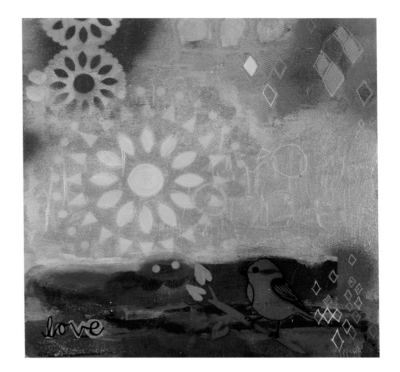

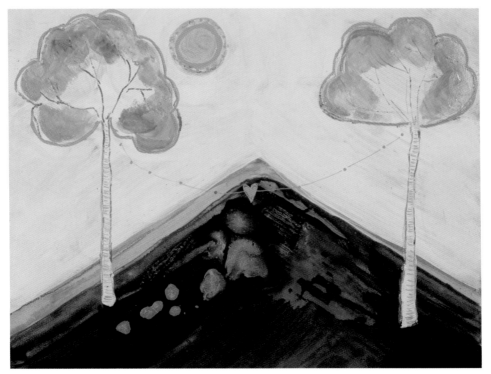

49 emotive release

Painting can be such sweet therapy when you're not worrying about outcomes and instead allowing color to pour out through you. Sit quietly for a few moments, perhaps even taking time to journal first, and let yourself channel any overwhelming or unwanted emotions and release them onto the surface, with each color you choose reflecting your mood. The results may surprise you. This technique can also be a wonderful way to help you get unstuck creatively.

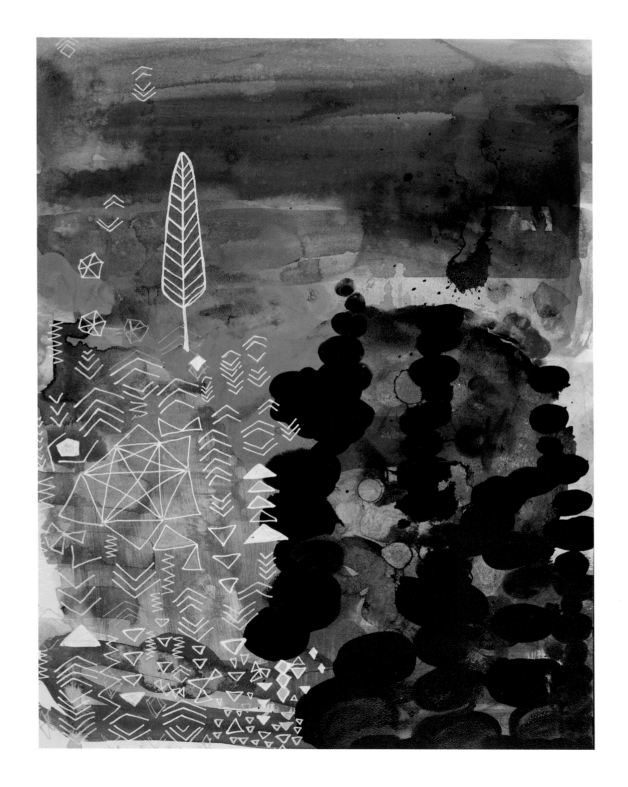

50 finger painting

Children instinctively want to paint with their fingers, so why not give yourself permission to play that way as an adult? I found this exercise quite liberating, because it provides a tactile way of connecting with the process. The whole painting doesn't necessarily have to be finger-painted—you can use your fingers to paint parts of it or even final touches and use other techniques for the rest, like I did in the bird's nest painting at right. I have found that acrylic paint is really the best medium to use for finger-painting.

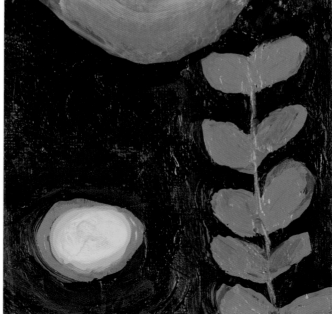

smear, erase

When you're working with inks and acrylics, smearing the paint with a paper towel (or even your fingers) while it's still damp can be a way to back up but still keep an underlying layer of color. You can also add paint by smearing a heavy layer of ink or acrylic onto the surface with your hand or paintbrush. Try this technique by playing with the two and see what takes place.

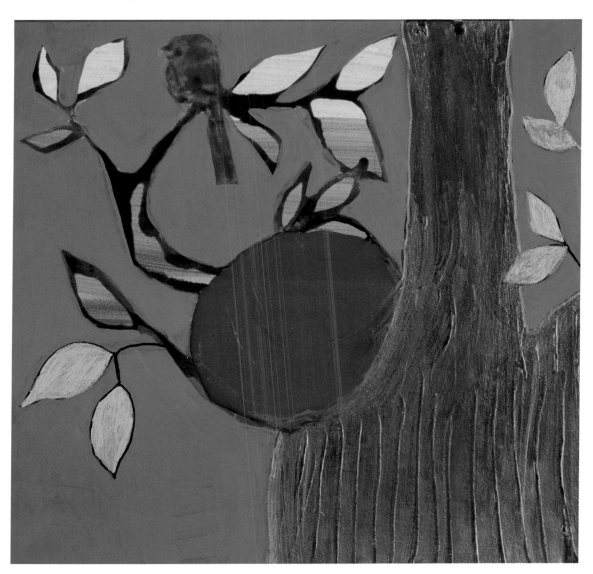

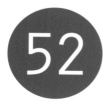

52 freehand ink

A brave, yet fun way to add a final layer to a painting is by making marks or lines directly from the ink bottle itself. Working boldly in a freehand style like this can build your confidence and allow you to trust your first instinct. I love using this technique to finish off a painting, because it adds a final touch that so clearly conveys a sense of being handmade. The ink lies thick atop any medium, which creates a strong statement and contrast.

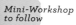

Mini-Workshop to follow

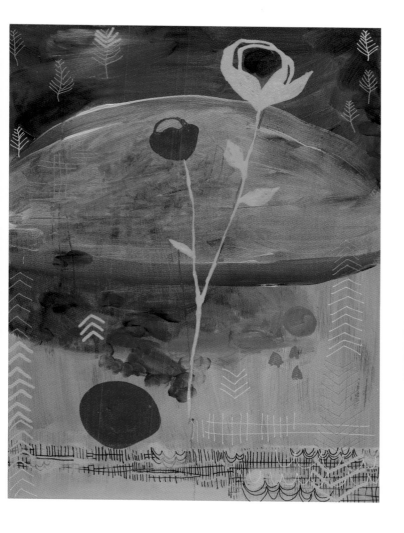

Freehand Ink
Mini-Workshop

you will need

- Painting surface of your choice
- Brushes
- Acrylic paint
- Acrylic or India inks
- Pencil (optional)
- Small round brush (optional)
- Liquid varnish or spray varnish (fixative)

(1) Create a painting on gesso, clay, or wood board, using acrylics, inks, paint pens, or even paper to collage if you want.

(2) In the final step, add acrylic or India ink directly from the bottle's dropper onto the painting. I like using a dark color to show contrast. You may sketch out lightly in pencil onto the painting first if working freehand feels too intimidating. You can also use a small round brush instead of the dropper bottle; it won't have quite the same effect, however.

(3) Wait until the painting is fully dry, and then seal it with a liquid or spray varnish (fixative).

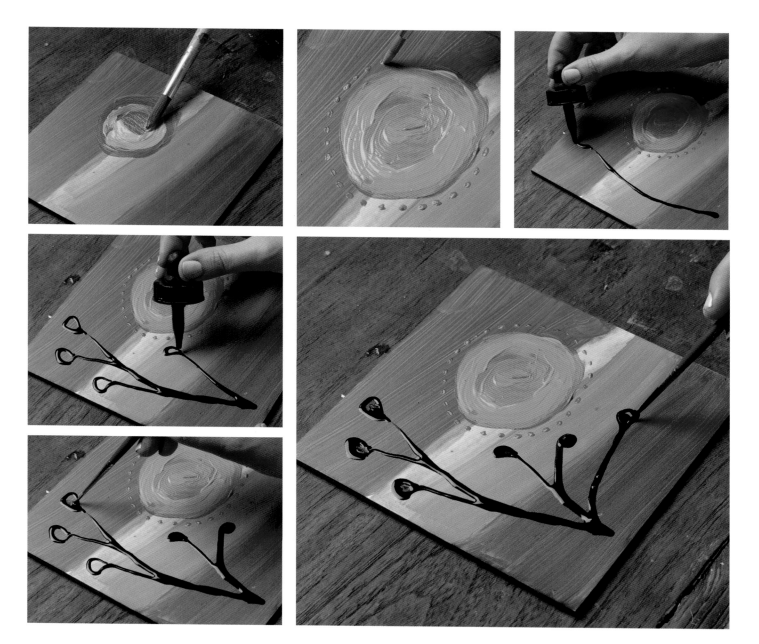

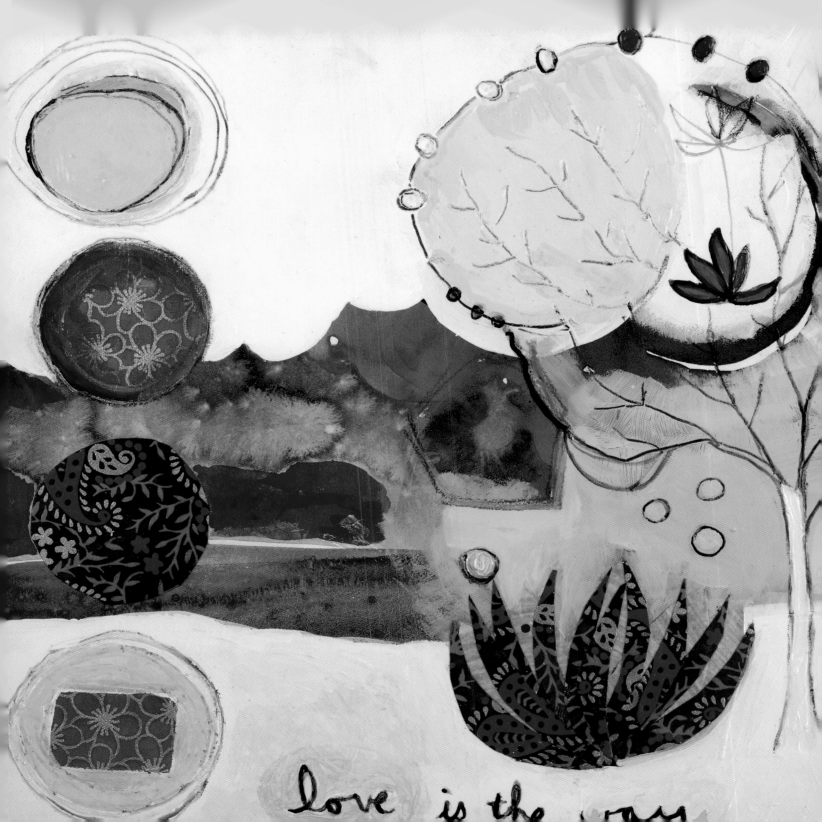

About the Author

Alena Hennessy does what she loves best, living life as a working artist, author, and workshop facilitator. She frequently travels across the States and abroad teaching her various methods of paint-ing and process, as well as hosting workshops online. She is deeply inspired to teach others to find their own authentic voice though art making.

Hennessy has also designed and created custom art for numerous business entities. Some current and past clients include: ABC Studios, Target, Urban Outfitters, Galison/ Mudpuppy Stationary, Project Iris, Papyrus, Monique Lllulier, Lark & Loon, and the City of Chapel Hill, North Carolina.

Her prints and giftwares can be found throughout the US and abroad. She has ex-hibited her paintings in galleries in major cities and has received press from several publications including *Dwell, Soul Body Connection, The Washington Post, Ready-Made, Redbook, Somerset Life, Amulet,* and *Natural Health* magazine.

Visit Alena online at www.alenahennessy.com.

Acknowledgments

To Nicole McConville, Becky Shipkosky, Steven Mann, Kathy Holmes, and all the other folks at Lark Books for making this possible. Thank you for your talent, kindness, and dedicated work ethic.

To my dearest family and friends, I love and adore you all completely. My world is lit up with magic because of your presence in it.

And finally to my fans, your support means way more than words could ever express. I am grateful for each and every one of you. This book is dedicated to you.

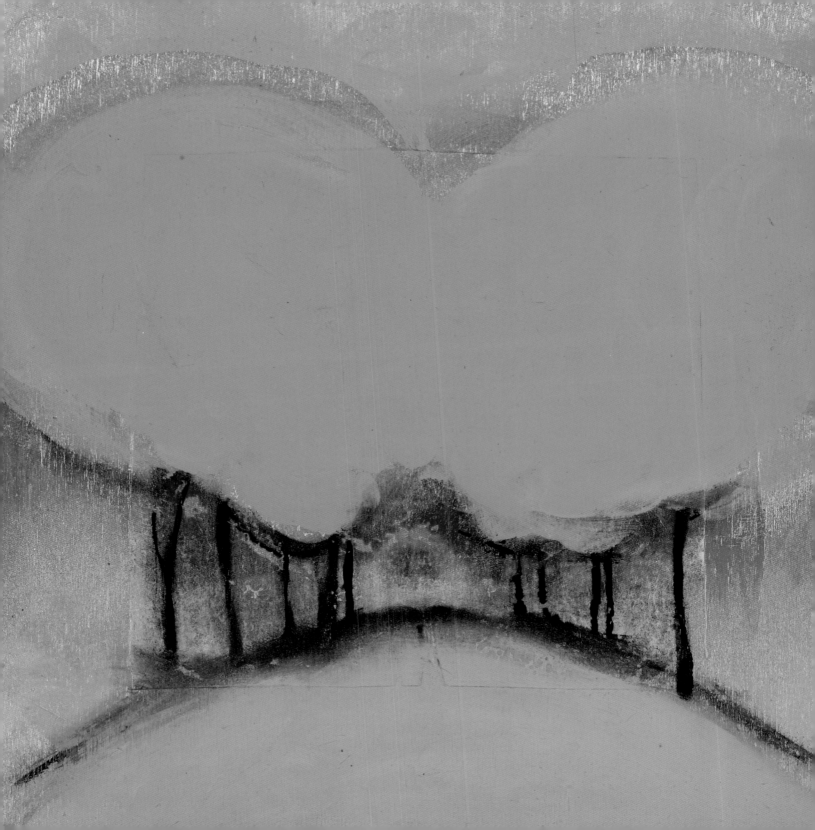

Index

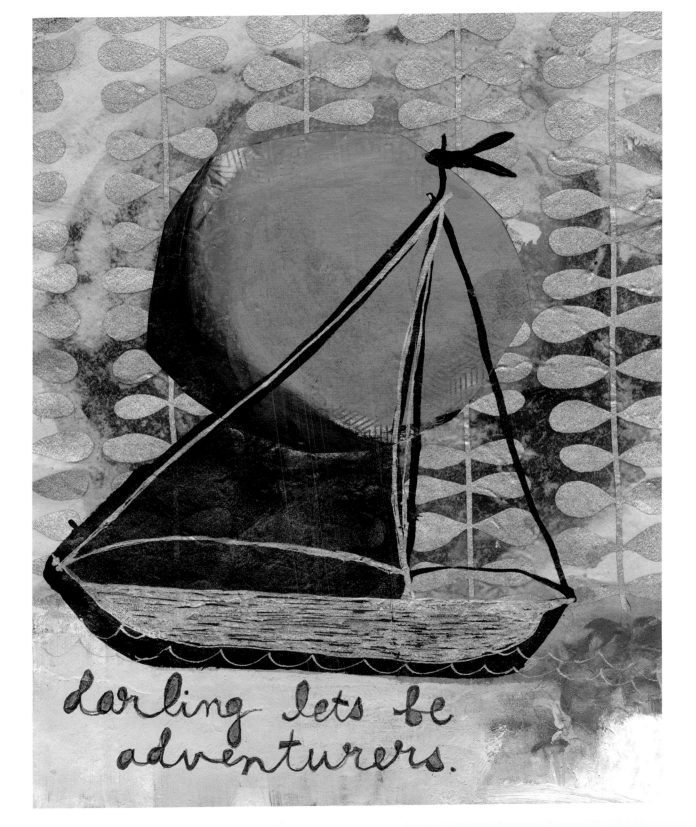

AMAZING SIGHTS OF THE SKY

Shooting Stars

by Martha E. H. Rustad

CAPSTONE PRESS
a capstone imprint

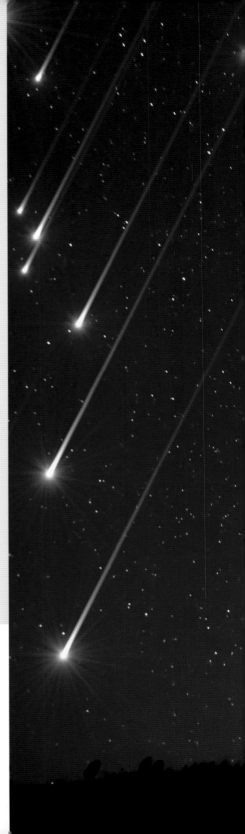

Pebble Plus is published by Capstone Press,
1710 Roe Crest Drive, North Mankato, Minnesota 56003
www.mycapstone.com

Library of Congress Cataloging-in-Publication Data
Library of Congress Cataloging-in-Publication data is available on the Library of
Congress website.
ISBN: 978-1-5157-6752-7 (library hardcover)
ISBN: 978-1-5157-6758-9 (paperback)
ISBN: 978-1-5157-6770-1 (eBook PDF)
Summary: Simple text introduces readers to the science behind shooting stars, including what a
shooting star is, what makes them visible, and when readers are most likely to see them.

Editorial Credits
Anna Butzer, editor; Juliette Peters, designer; Wanda Winch, media researcher;
Steve Walker, production specialist

Photo Credits
European Space Agency: Rosetta/NAVCAM-CC BY-SA IGO 3.0, 15; iStockphoto: 4kodiak, 5;
Science Source: David Nunuk, 21, Thomas Heaton, 9; Shutterstock: Allexxandar, 19, Bjoern
Wylezich, 11, Cylonphoto, 1, Procy, 13, SKY2015, shooting stars background, 17, Yuriy Mazur,
cover; Thinkstock: iStockphoto/ikonacolor, 7

Note to Parents and Teachers

The Amazing Sights of the Sky set supports national science standards related to earth science. This
book describes and illustrates shooting stars. The images support early readers in understanding
the text. The repetition of words and phrases helps early readers learn new words. This book also
introduces early readers to subject-specific vocabulary words, which are defined in the Glossary
section. Early readers may need assistance to read some words and to use the Table of Contents,
Glossary, Read More, Internet Sites, Critical Thinking Questions, and Index sections of the book.

Printed and bound in China
PO004674

Table of Contents

What Is a Shooting Star?

Stars shine brightly in the night sky.

One bright light streaks by.

It is a shooting star!

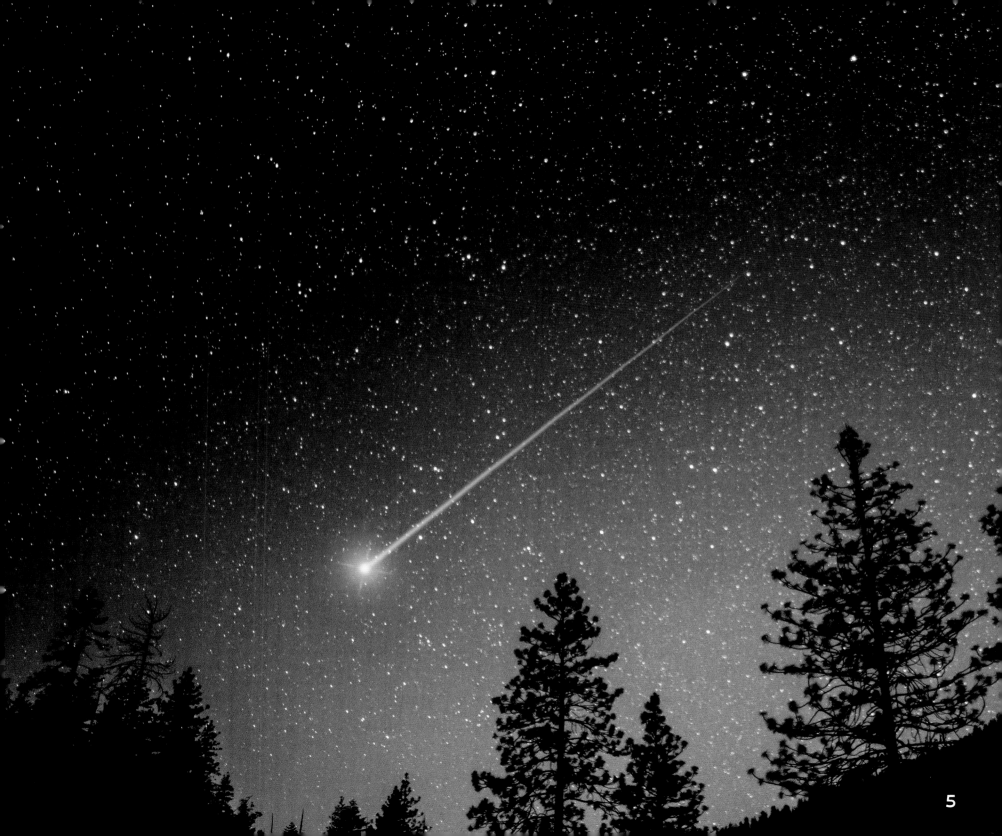

Shooting stars are also called meteors. A meteor is a burning space rock.

7

Burning Meteors

Some meteors come near Earth.

Earth's gravity pulls them down.

Gases around our planet make

meteors burn. They look like a streak

because they fall quickly.

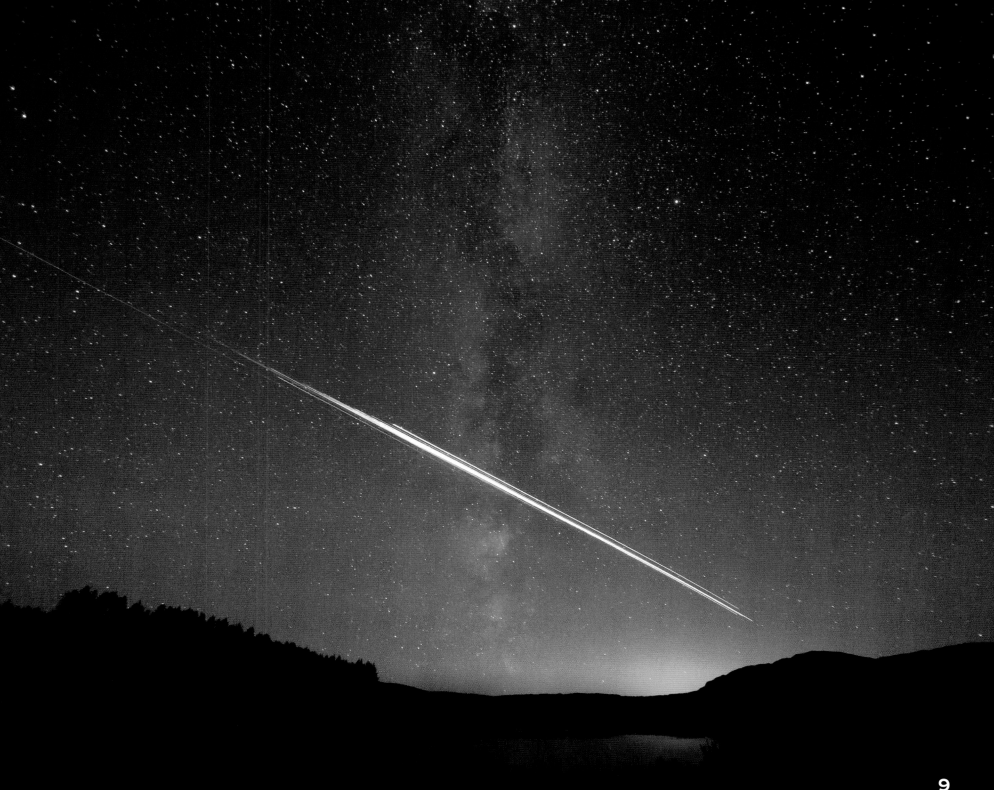

Most meteors burn up
and disappear.

But a few hit planets.

These rocks are then
called meteorites.

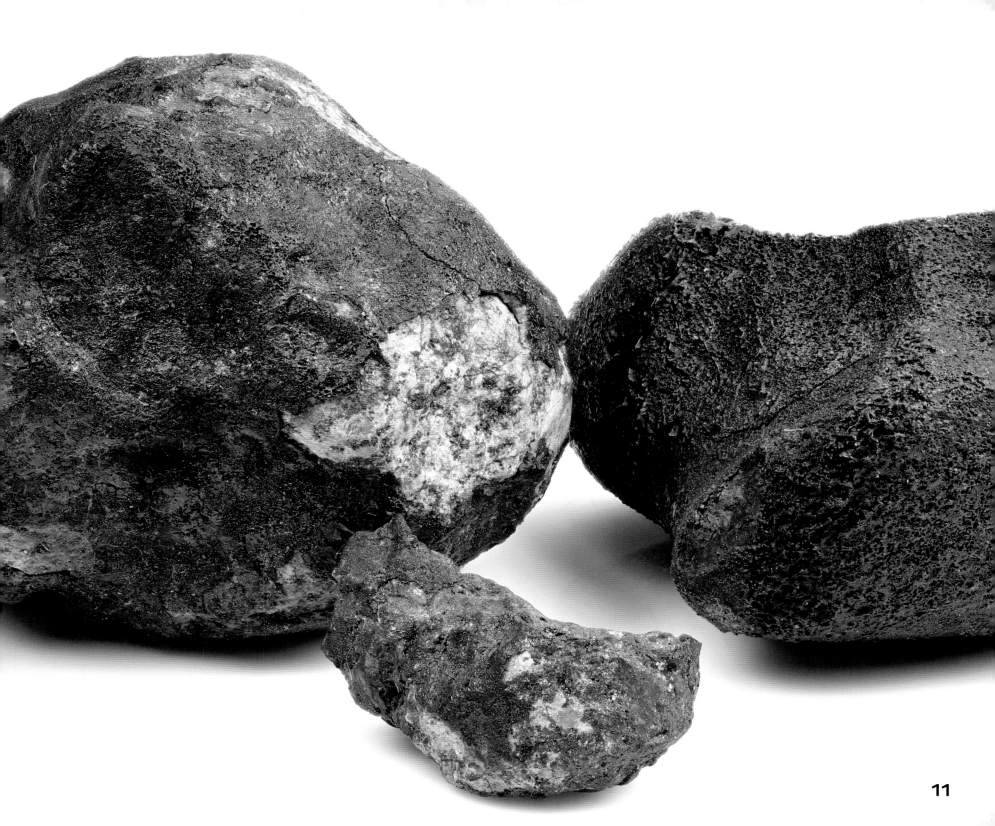

Meteorites make craters.

Craters are dents or holes

in planets. The moon

has craters from meteorites too.

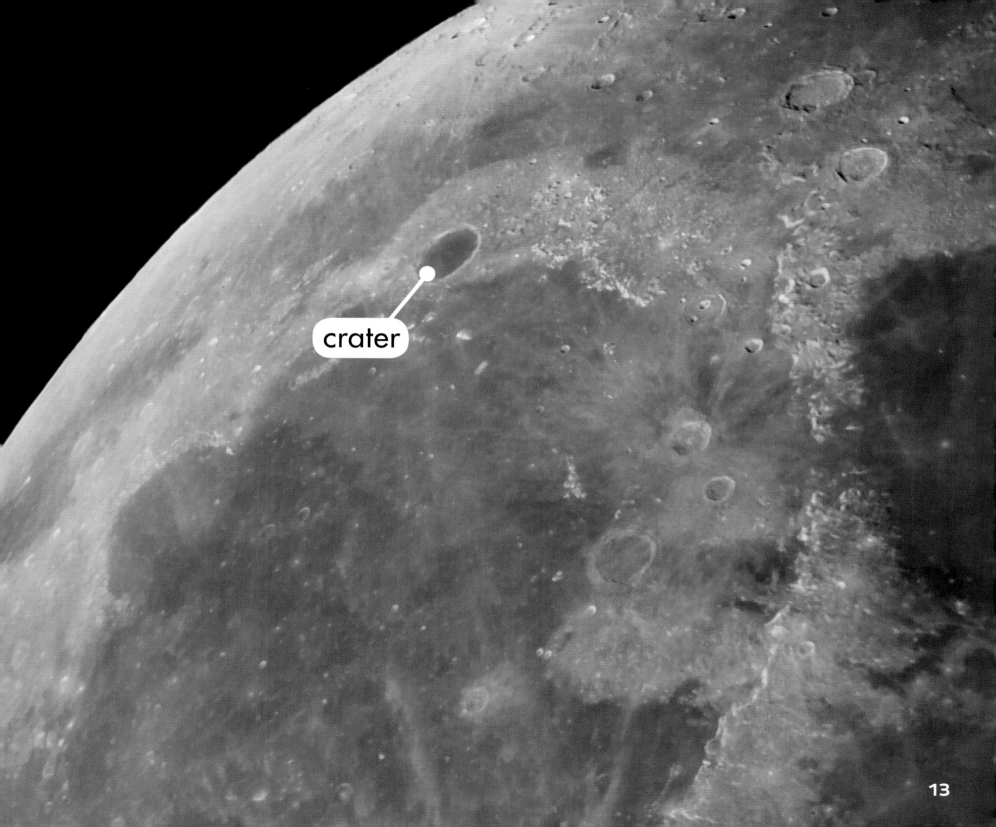

crater

Meteor Showers

Comets are big pieces

of rock and ice.

They orbit the sun.

Comets leave a trail of dust

behind them.

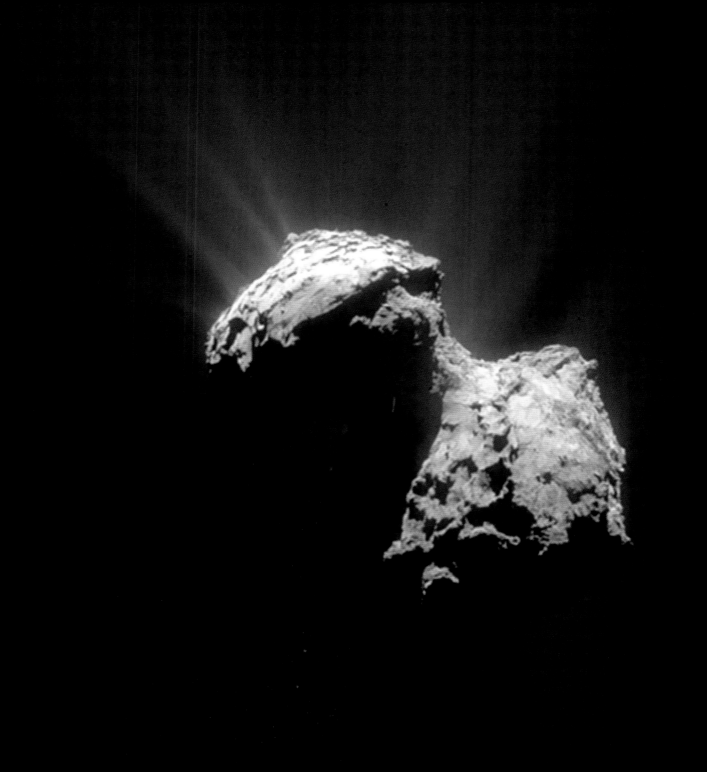

Sometimes Earth passes through leftover comet dust.

It creates hundreds of shooting stars.

It's called a meteor shower.

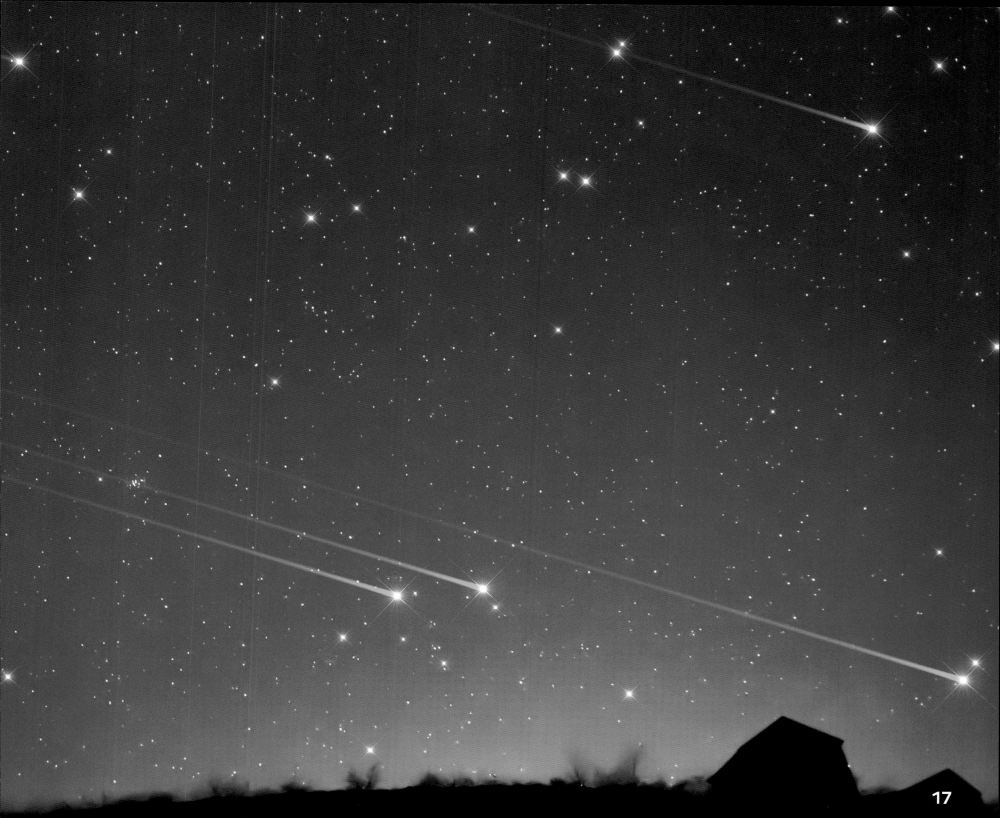

See a Shooting Star

Astronomers keep track of comets and meteor showers.

Some meteor showers happen around the same time each year.

Check this chart to see when a meteor shower will happen.

Lyrids	mid-April
Perseids	July or August
Orionids	October or November
Leonids	November
Geminids	early to mid-December

Go away from the lights of the city.

Let your eyes adjust to the dark.

Watch for shooting stars.

You will see an amazing sight!

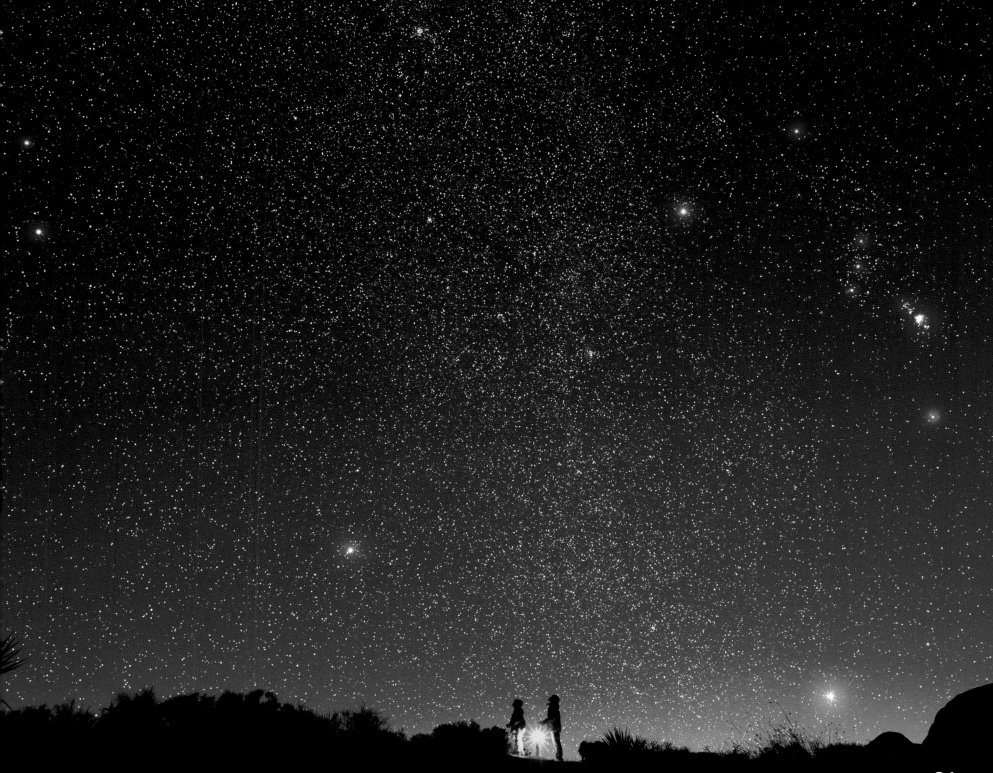

GLOSSARY

astronomer—a scientist who studies stars, planets, and other objects in space

comet—a big piece of rock and ice that orbits the sun

crater—a dent or hole

gravity—a strong force that pulls objects together

meteor—a space rock that burns up in Earth's atmosphere

meteorite—a space rock that hits Earth's surface or the surface of another planet

orbit—a path that an object follows in space

planet—a large space body that orbits a star

sun—the large star at the center of our solar system

READ MORE

Hunter, Nick. *Stars and Constellations.* The Night Sky: And Other Amazing Sights in Space. Chicago: Heinemann, 2014.

Orr, Tamra B. *I See Falling Stars.* Tell Me Why. Ann Arbor, Mich.: Cherry Lake Publishing, 2015.

Rajczak, Kristen. *Shooting Stars.* Nature's Light Show. New York: Gareth Stevens Pub., 2013.

INTERNET SITES

Use FactHound to find Internet sites related to this book.

Visit *www.facthound.com*

Just type in 9781515767527 and go.

Check out projects, games and lots more at
www.capstonekids.com

CRITICAL THINKING QUESTIONS

1. What do comets leave behind them?
2. What makes shooting stars burn?
3. How can you increase your chances of seeing a meteor shower?

INDEX